KT-460-124

THE ISLANDS

to
SHEILA COCHRANE

SCOTTISH
MOUNTAIN DRAWINGS

THE
ISLANDS

A Wainwright

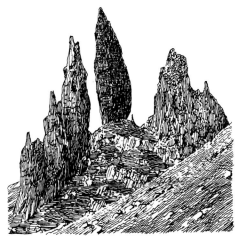

Skye : The Old Man of Storr
and his family

PUBLISHED *by* FRANCES LINCOLN, LONDON

PUBLISHER'S NOTE

The Islands was originally published as Volume Six in a series of collections of Scottish mountain drawings. The drawings were numbered throughout the series rather than by individual volume, so the first drawing in The Islands is number 376. The introduction to Volume One of the series – in which Wainwright explains the spirit in which the project was conceived – is reprinted in full on the pages immediately following this note.

Frances Lincoln Limited
4 Torriano Mews
Torriano Avenue
London NW5 2RZ
www.franceslincoln.com

First published by Frances Lincoln 2006
Originally published by Westmorland Gazette, Kendal, 1979

Copyright © The Estate of A. Wainwright 1979

All rights reserved. Without limiting the rights under copyright reserved above, no part of this publication may be reproduced, stored in or introduced into a retrieval system, or transmitted, in any form or by any means (electronic, mechanical, photocopying, or otherwise), without either prior permission in writing from the publisher or a licence permitting restricted copying. In the United Kingdom such licences are issued by the Copyright Licensing Agency, 90 Tottenham Court Road, London W1T 4LP.

Printed and bound in Singapore

A CIP catalogue record is available for this book from the British Library.

ISBN 0 7112 2591 5

INTRODUCTION

The introduction to this book ought really to be prefaced by an apologetic explanation of the reason why a sassenach, and a Lancashire sassenach at that, should presume to offer a book about Scotland, and on a subject, moreover, so exclusively Scottish as the Highlands.

Well, it's like this. I have had two great ambitions in my life, and neither has been satisfied by achievement. One was to be the first man on the summit of Everest, and, after tormenting me for thirty years, this bubble burst on Coronation Day 1953. The other was to climb to the top of every Munro in Scotland, and this proved to be a pipe dream too. Everest, for me, was palpably unattainable; the Munros were a more practicable challenge but my plans never got off the low ground. I was fettered to a desk in England all my working life and although in my brief annual holidays I always headed north over the Border I could never resist the lure of a full tour around the mountains, by train and MacBrayne, rather than halt at the foot of one peak when so many were to be seen by moving on. I did the rounds year after year and had nothing to show except an album of a thousand photographs.

Retirement came in due course and with it a last opportunity, late in the day. Too late, alas. My mind had not lost enthusiasm but my legs had; and I was heavily committed with other work. I still went to Scotland, indeed more often, but only to admire, not to climb. More years went by thus. Then one day an idea stirred and quickly fanned into an aspiration..... If I couldn't climb all the 276 Munros, perhaps it wasn't too late, even yet, to visit them all, to track those I had never seen simply because they were too remote — not to climb them but to get myself to viewpoints where I could see them in perspective, and compile a collection of drawings of them. This is the pleasurable task I am engaged upon. I am getting rid of an itch.... So the reason for the book is a love of the Scottish Highlands.

now for the introduction proper.

In 1891 Sir Hugh T. Munro listed all the Scottish mountains over 3000 feet in altitude, classifying them in districts and in descending order of height, a total (revised) of 276, Ben Nevis, 4406', being number 1 and Càrn Aosda, 3003', number 276. Thereby he lit a flame — his Tables were published and became well known in mountaineering circles, the 276 mountains became commonly known as Munros and presented an obvious challenge that many climbers have accepted. 'Munro-bagging', 'collecting' Munros by ascending to their summits, is an esteemed sideline of Scottish mountaineering, a long-established ritual for dedicated enthusiasts. Sir Hugh compiled his Tables with such care that, although subjected to occasional minor revision, they remain substantially unchanged. The Tables (1969 edition) have been regarded as gospel, so far as details of altitude and precedence are concerned, in the preparation of this book, although recent issues of the 1" Ordnance map show corrections to the original heights of a few of the mountains and thereby call for further slight amendments. In this book a bracketed number following the title of a drawing of a Munro indicates the order of precedence in the Tables. For example (M.58) means a Munro and the 58th highest mountain listed in the Tables.

Difficulties arise in determining the correct spellings of many of the mountain names, which are almost invariably in Gaelic, different versions being in use in some cases. The Ordnance Survey spellings are often suspect and inconsistent but have been adopted in Munro's Tables and are therefore used in this book. *Alternative spellings in general use are given in brackets under the titles of the drawings.*

Mountain names in Scotland, unlike those in England, usually incorporate as a prefix an equivalent of 'mountain' but these too are variously spelt as *Ben, Beinn* and *Bheinn*. In many cases the name of a feature is substituted, thus *Sgòrr, Sgùrr* and *Sgòr* (= scar); *Maol, Meall, Mheall, Meallan, Mam,* and *Maoile* (hill); *Stùc, Stac* and *Stob* (peak); *Bidean* (little peak); *Spidean* (sharp peak or pinnacle); *Creag* (crag); *Carn* (cairn). Confusion is worse confounded by inconsistency in the accenting of vowels: *More* (big) appears also as *Mor, Mòr, Mhor* and *Mhòr*. An English climber in Scotland thinks affectionately and with nostalgia of the simple mountain names of his own Lake District: Helvellyn, Glaramara, Blencathra, Great Gable: lovely names, pronounceable and straightforward.

As regards pronunciation of Gaelic names the average visitor from south of the Border simply has to give up. When *Chlaidheimh* is pronounced *Clay*, *A'Mhaighdean* *AA-vi-ee-chun*, *Choire Leith* *Horrie Lay* and *Ceathreamhnan Cerranan* there is no hope for the unlearned — and ignorance suffers worse frustration when names that look ugly roll off a Highlander's tongue like sweet music. *No attempt has been made to give pronunciations except for just a few of the better known mountains where there seems to be general agreement.*

English translations of Gaelic names have been given where known, and freely adopted from the excellent guidebooks of the Scottish Mountaineering Club. But in the matter of interpretation, too, there is cause to wonder at the complexities of the language. For example, *Beinn Bhàn, Sgùrr Bàn, Fionn Bheinn, Foinaven* and *Foinne Bhein* all have the same meaning: "the white mountain." *English translations are given in brackets, where known, following the titles of the drawings.*

There is a crying need for a Royal Commission composed of Gaelic scholars and oldest inhabitants and Scottish mountaineers, with a representative of the Ordnance Survey also in attendance, to examine Highland nomenclature and agree upon (a) correct spellings, (b) correct pronunciations and (c) correct interpretations. This is not to suggest that Gaelic names should be Anglicized, far from it, but merely that bewildered visitors who like to wander amongst the Highlands should be let into the secrets of the language. When you have climbed a mountain it is nice to be able to say so and to say which, rather than avoid mention of the name because you cannot pronounce it.

In this book altitudes are recorded in feet, not the newfangled metres, and distances in Scottish miles, not foreign kilometres. You can't teach an old dog new tricks; some old dogs simply refuse to learn.

Mention has been made of the guidebooks of the Scottish Mountaineering Club. These are not only invaluable aids for the walker who tramps over the hills but have also very considerable merit as literature. The original editions in particular are written in prose that reads like poetry and were at the time absolutely accurate in all details; the later revised editions now current just lack that touch of class but are essential because of many topographical changes brought about by recent hydro-electric schemes and the resultant loss of certain paths.

To an artist with sketchbook or camera the Scottish mountains have helpful attributes: most of them are both photogenic and accommodating, scoring heavily over the English because they present themselves in much better perspective, their steepening concave slopes often rising sharply from flat ground and so permitting full summit-to-base views. To avoid a foreshortening effect a distance of about four miles is generally preferable if a viewpoint can be found that is not interrupted by intervening high ground, and a flat or descending foreground is an advantage in emphasising the stature of the subject. The ideal viewpoint is an opposite slope at rather less than mid-height with a valley between, looking along the line of a watercourse descending from the summit. Many good sightings are obtained from the vicinity of the motor roads with no more walking than is necessary to find an interesting foreground. If a fair distance needs to be covered on foot to bring a mountain into full view, advantage should be taken, if feasible, of the paths shown on the Ordnance maps: these, often made and maintained by stalkers, are invariably easy to follow and firm underfoot because they are not over-used. The crossing of rough flat ground in the Highlands without a path to guide can be a serious undertaking, consuming more time, burning up more energy and invoking more bad temper than climbing a steep slope..... And another most important and most endearing feature of the Scottish mountains is their usual clear visibility and freedom from haze. Bless them for that.

When a lover of the Highlands is too old to climb he can find compensation with a good camera and his tattered Ordnance maps and a copy of Munro's Tables. And a photograph album with 276 spaces. The Munros offer a different late-in-life challenge to the old-timer who can still cover ground on foot to bring them into view: he can 'do' the Munros in a new way, hunting them with his camera and filling the spaces one by one, and so bringing a rewarding fresh interest to his later years.
He will be a proud and happy man when the last space is filled.

aw
February 1974

THE WESTERN ISLES

The drawings are arranged in six sections, each one preceded by an outline map and a narrative. The drawings are accompanied by a comment and a simple location map (on the scale of two miles to an inch, north being at the top) or, in some cases, a diagram. The viewpoint is shown on each map thus: ⊗ and the limits of the range of view are indicated by broken lines thus: ⊗

There are 13 Munros in the Western Isles (12 in Skye; 1 in Mull)

A bracketed number following the title of a drawing of a Munro indicates the order of precedence in Munro's Tables. For example, (M.58) = the 58th highest mountain listed in the Tables.

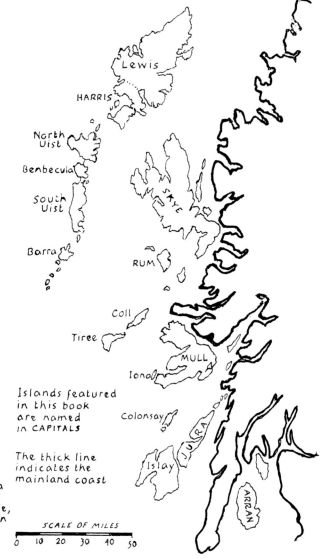

Islands featured in this book are named IN CAPITALS

The thick line indicates the mainland coast

SCALE OF MILES

0 10 20 30 40 50

THE DRAWINGS IN THIS BOOK
in the order of their appearance:

continued

continued

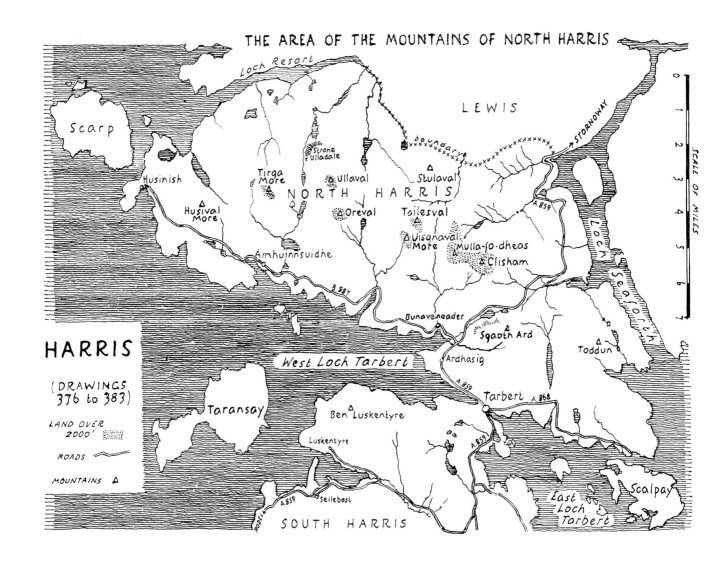

THE AREA OF THE MOUNTAINS OF NORTH HARRIS

Loch Resort

Scarp

LEWIS

Boundary

STORNOWAY

Husinish

Strone Ulladale

Tirga More

Ullaval

NORTH HARRIS

Stulaval

Husival More

Oreval

Toilesval

Uisgnaval More

Mulla-fo-dheas

Clisham

Loch Seaforth

Amhuinnsuidhe

B 887

Bunaveneader

Sgaoth Ard

Toddun

Ardhasig

A 859

HARRIS

(DRAWINGS 376 to 383)

West Loch Tarbert

Tarbert

A 868

LAND OVER 2000'

ROADS

MOUNTAINS △

Taransay

Ben Luskentyre

A 859

Luskentyre

A 859

Seilebost

SOUTH HARRIS

East Loch Tarbert

Scalpay

SCALE OF MILES

0 1 2 3 4 5 6 7

Harris is the southern part of the largest island of the Outer Hebrides, sharing a common land boundary with the more extensive Lewis. Although the boundary is political it also marks a pronounced natural difference in the character of the terrain, Lewis being almost entirely composed of peat moorland with few hills, Harris being mountainous with a greater variety of landscapes, and more scenically attractive.

Harris itself is almost bisected across its middle by two sea-lochs, East and West Loch Tarbert, which penetrate deeply into the coastline, forming a narrow isthmus and providing sheltered anchorages. Here is the 'capital', Tarbert, a village with tourist accommodation, shops and a harbour.

The principal mountains form a continuous range in North Harris above the rocky and indented shore of West Loch Tarbert. None of them attains Munro status but because they rise sharply from sea level they appear to be of great height, an impression emphasised by soaring pyramidal peaks that add a special distinction to the scene. Most visitors to Harris arrive at Tarbert and travel on the Stornoway road, two miles along which they are suddenly confronted by the whole range of these mountains from end to end — a most compelling sight. The highest is Clisham, 2622', in the east: the others, separated by deep glens, extend westwards to the Atlantic shore. In the interior, behind this formidable mountain facade, is the great crag of Strone Ulladale, the highest cliff in the British Isles.

Those who visit Harris to climb its mountains, or merely to look at them, should find time also to explore the other attractions of this wonderful region and visit South Harris in particular. Here grey rock, mainly gneiss, outcrops everywhere in great sweeps, giving a strange eeriness to landscapes as old as time. The eastern seaboard especially is all rock, a contorted labyrinth of bays and inlets and coves and lochans where crofters still live the life of their fathers : fishing, weaving, tilling vegetable plots that are no more than narrow strips of peat and seaweed laid on or between the bare rocks; there is no farming, no grazing land. On the west coast conditions are less harsh : there is a succession of glorious beaches of shell-sand, white in sunlight with the sea shading into exquisite translucent colours, from deep blue to turquoise and delicate pastel green; the sand blown inland nurtures grassy and flowery pastures.,.. And, of course, Harris is famous internationally for its tweeds, and it is interesting to find tiny cottages in which the weaving of wool on small looms is expertly undertaken — a home industry with a world market.

Harris is a place of splendid mountains and delightful surprises.

Clisham is the highest mountain in Harris and indeed the highest in the islands of the Outer Hebrides. From most directions it takes the form of a wide dome, but from the Stornoway road to the south-east it appears as a very graceful peak

376 Clisham, 2622'

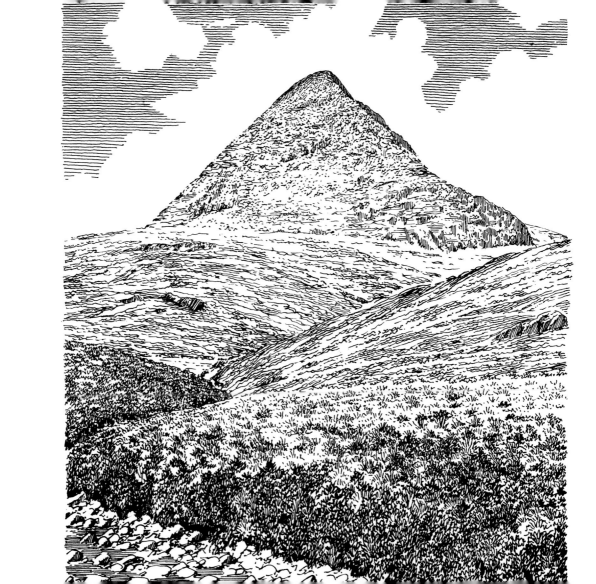

Mulla-fo-thuath, 2360'
Mulla-fo-dheas, 2439'
Ant-Isean, 2280'
Clisham, 2622'

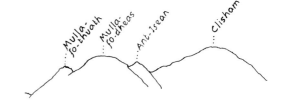

377 The Clisham group, from Ardhasig

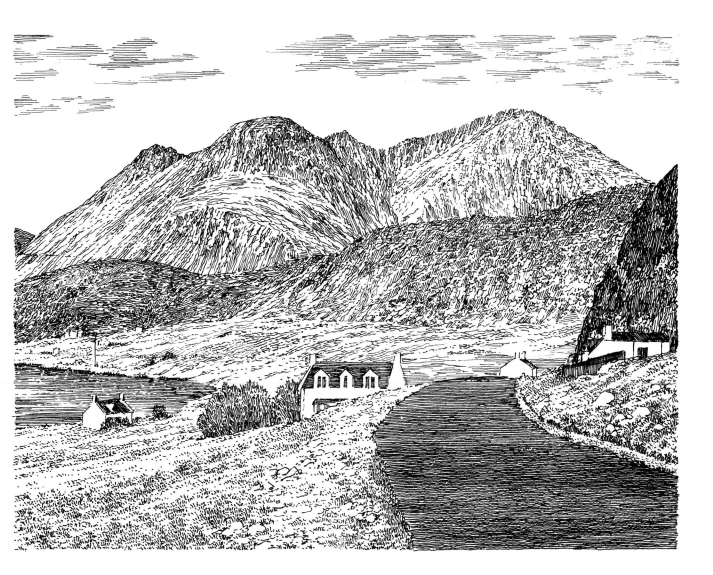

Clisham An t-Isean Mulla-fo-dheas Mulla-fo-thuath

378 The Clisham group, from Scaladale

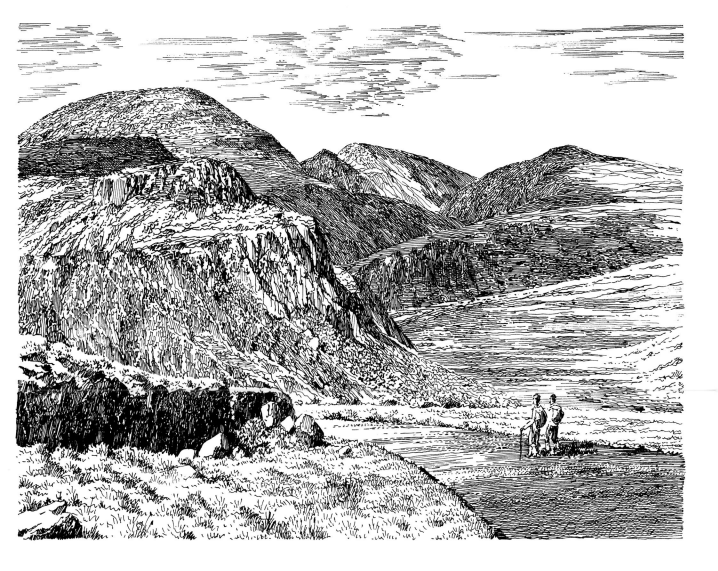

The narrow switchback road to Husinish provides grandstand views of almost all the mountains west of Clisham as one proceeds along it, and they can be seen to perfection without leaving the car. A striking feature of Uisgnaval More is the terminal precipice of Strone Scourst.

379 Uisgnaval More, 2393'

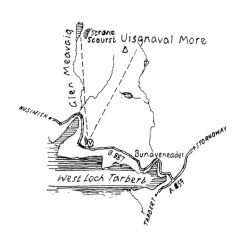

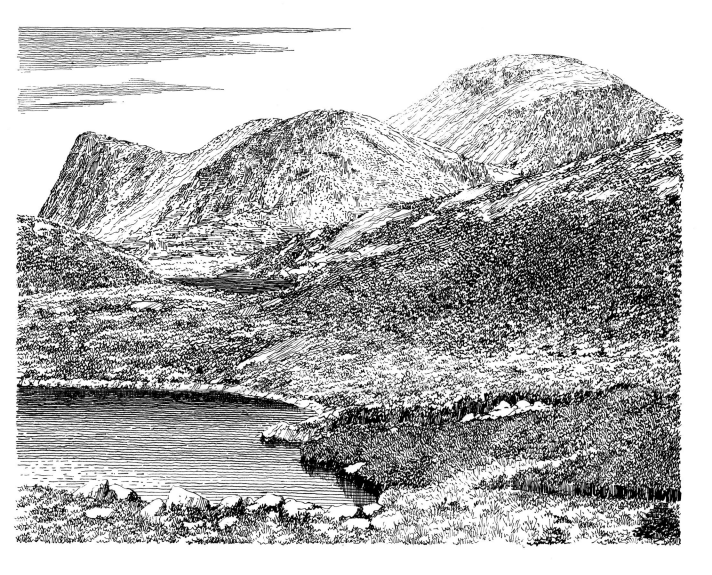

Rounding the headland at Ardhasig, on the west road out of Tarbert, there comes into view, suddenly and with dramatic effect, the finest mountain scene in Harris. Centrally placed and directly ahead across the waters of West Loch Tarbert rise the splendid twin peaks of Uisgnaval More and Toilesval — an impressive sight compelling a roadside halt.

380 Uisgnaval More, 2393'
and
Toilesval, 2272'

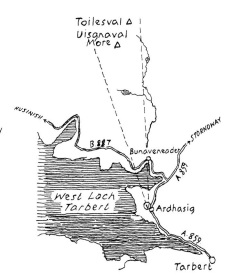

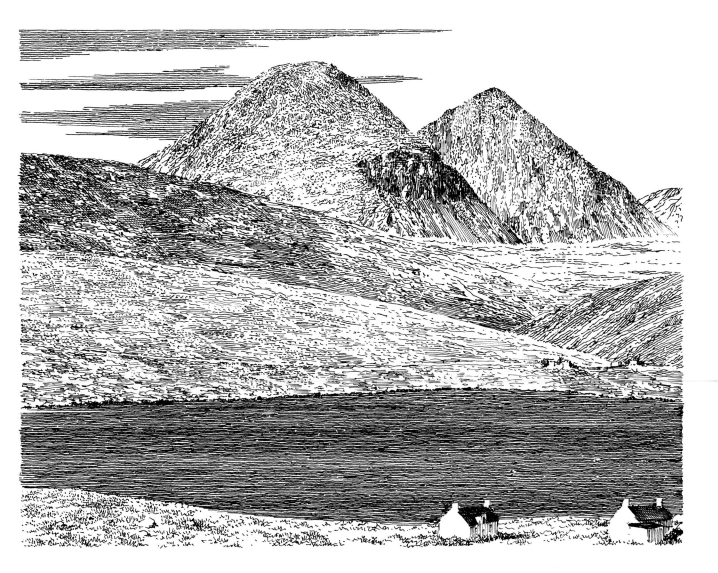

Oreval is the middle one of the three principal heights seen from the Husinish road. From its summit a ridge continues north to Ullaval, 2153', before declining to end abruptly in the massive overhanging cliff of Strone Ulladale.

381 Oreval, 2165'

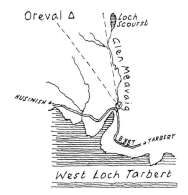

Oreval △ Loch Scourst
Glen Meavaig
HUSINISH
B.887 TARBERT
West Loch Tarbert

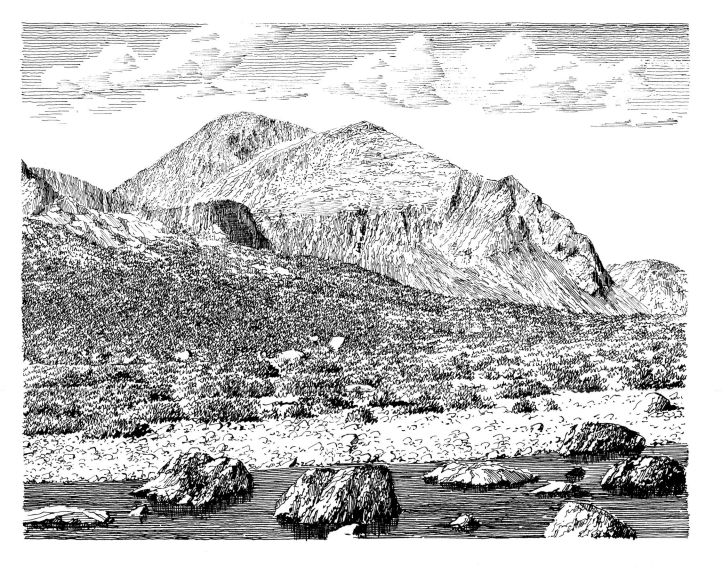

The great characteristic of Harris is the liberal outcropping of gneiss, its light grey colour giving the mountains a pallid appearance. It occurs everywhere and is especially in evidence on Tirga More, notably on the eastern flank, the surface rock rising in a succession of 'boiler-plate' slabs.

382 Tirga More, 2227'

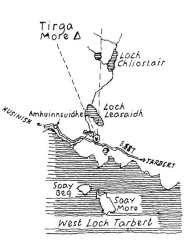

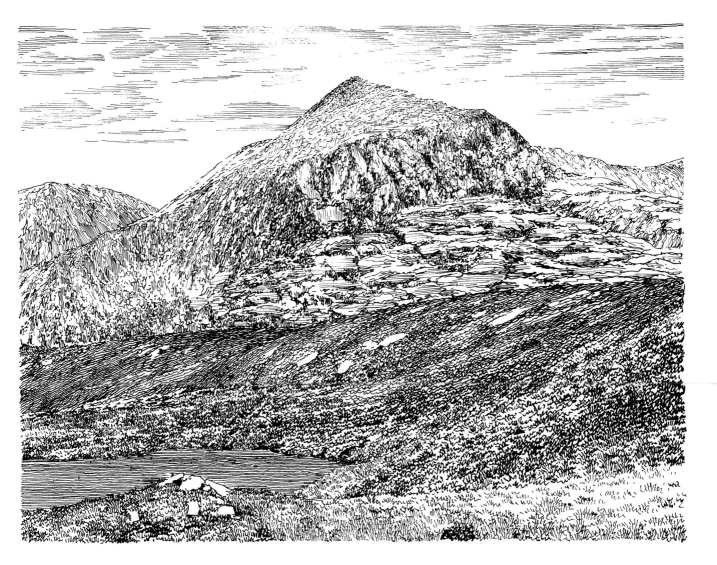

The white sands of Husinish (also variously spelt Hushinish and Huishnish) make a beautiful foreground to the heathery western terminus of the mountains overlooking West Loch Tarbert. From Husival More the high ground descends to the Atlantic. Husinish is the end of the road, the end of everything.

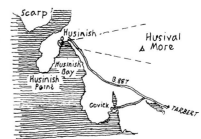

383 Husival More, 1603'

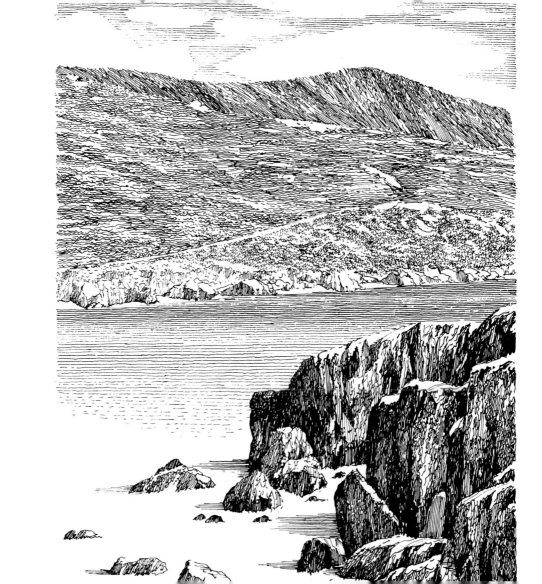

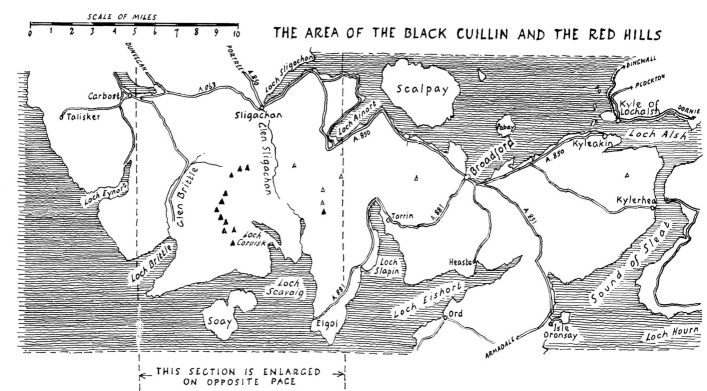

SKYE

(DRAWINGS 384 to 423)

MOUNTAINS OVER 3000'
INCLUDED IN MUNRO'S TABLES ▲
OTHER MOUNTAINS ILLUSTRATED △
PUBLIC ROADS ══ RAILWAY (mainland) ┿┿┿┿

SCALE OF MILES
0 1 2 3 4 5 6 7 8 9 10

THE AREA OF THE BLACK CUILLIN AND THE RED HILLS

DUNVEGAN

PORTREE

A.850

Loch Sligachan

Scalpay

DINGWALL

PLOCKTON

Carbost

A.863

Kyle of
Lochalsh

DORNIE

Talisker

Sligachan

Loch Ainort

A.850

Pabay

Loch Alsh

Glen Sligachan

Broadford

Kyleakin

A.850

Loch Eynort

Glen Brittle

Kylerhea

Loch
Coruisk

Torrin

A.881

Heasted

Loch Brittle

Loch
Scavaig

Loch
Slapin

A.851

Sound of Sleat

Soay

Elgoi

A.881

Loch Eishort

Ord

Isle
Oronsay

Loch Hourn

ARMADALE

← THIS SECTION IS ENLARGED →
ON OPPOSITE PAGE

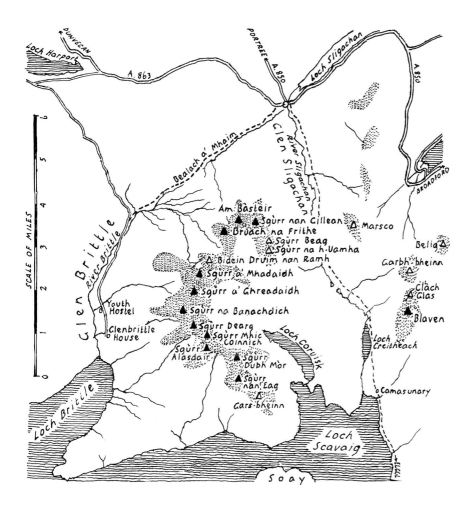

THE CUILLIN

LAND OVER 2000' ▦

MOUNTAINS OVER 3000'
INCLUDED IN
MUNRO'S TABLES ▲

OTHER MOUNTAINS
ILLUSTRATED △

PUBLIC ROADS ────

PRINCIPAL PATHS ─────

The Black Cuillin form a continuous high ridge of naked rock rising to a succession of well-defined sharp peaks in close array between Glen Brittle and Glen Sligachan. Eleven of these distinctive peaks are classed as Munros. An outlier, Blaven, in similar mould, is also a Munro.

East of Glen Sligachan are other summits of the Cuillin, more rounded in appearance, less exciting in outline: the Red Hills.

The marked differences in character between the Black and the Red are due to the nature of the rock, the Black being composed of gabbro and basalt, the Red of granite.

Few who have seen, or walked or climbed upon, the Black Cuillin of Skye will dispute the statement, often made, that this spectacular array of rock pinnacles and peaks is the grandest mountain group in the British Isles.

Taking the form of a curving ridge no more than eight miles long and occupying no more ground than many a single mountain elsewhere, such as Ben Avon, the Black Cuillin are wonderfully concentrated in small space, so that the summits of quite separate mountains are often only a few hundred yards apart, although the deep and craggy gulfs between call for rockclimbing skills in traversing from one to the next. Indeed the crest of the ridge and the slopes immediately below are composed almost wholly of naked rock with steep crags soaring into pinnacles and towers, the highest forming the mountain summits, eleven of which exceed 3000 feet and qualify as Munros, all within a relatively short distance. The close proximity of the peaks, seen from afar or on a map, is misleading they are compactly grouped but much time and effort is entailed in negotiating an easy passage over the difficult ground between the tops, while in many places progress is barred to all but experienced cragsmen. The traverse of the ridge from end to end is an arduous expedition requiring advance planning and grim determination and can be accomplished only by those accustomed to the scaling of precipitous rocks. At a few points only the ridge can be attained by rough walking and scrambling, giving the non-climber an opportunity of sampling the excitement and awe-inspiring views peculiar to the Cuillin. The easiest access to the ridge is by way of the northwestern shoulder of Bruach na Frithe, from the top of which, fortuitously, there is an excellent prospect of the spine of the ridge and most of the peaks. But in general this is not hillwalking terrain — the Black Cuillin are out of bounds for those who prefer to tread sedately and certainly for sufferers from vertigo. Fortunately for the rescue teams the appearance of these mountains is daunting: at a glance it can be seen that ascents will be extremely difficult and even dangerous, if possible at all. This is exclusively mountaineering country, for experts. No other mountains compare with these. The Black Cuillin are both harsh fact and pure fantasy.

Across the profound gulf of Glen Sligachan is the striking skyline of another rocky ridge, culminating in majestic Blaven, also a Munro. Neighbouring Blaven and extending eastwards to Kyle Rhea are several more considerable heights, less awesome in appearance and less attractive, with a covering of pink granite scree that has earned for them the name of Red Hills.

In the far north of the island the peninsula of Trotternish is notable for a backbone of rock, around 2000 feet above the sea and continuous for 15 miles, with several summits, and for the ordinary hillwalker the traverse of this long escarpment is the best high-level expedition in Skye. Here are two very remarkable areas of weather-eroded rocks, Quiraing and The Storr, each providing an exceptional display of sharp pinnacles in the shelter of imposing crags: a most impressive sight.

Elsewhere on the island there are wide areas of dreary moorland unrelieved by trees, and mile after mile of uninspiring landscapes, Skye without its mountains would be a dull place. With its mountains, and especially the Black Cuillin, it is the finest place on earth for the British climber who rates his native hills the best of all. To him, Skye is Mecca, spelt differently.

Accommodation conveniently sited for the Black Cuillin is very sparse. There is a well-known hotel at Sligachan, made famous by the pioneers of climbing in Skye, and at Glen Brittle visitors are catered for by a Youth Hostel, a large camping and caravan site and a limited amount of private lodgings. Otherwise a car is necessary. Elsewhere, and especially at Portree, Broadford and Kyleakin, new and enlarged hotels testify to the growing influx of visitors. Not very long ago a visit to Skye was an adventure, bad roads and poor communications combining to make the journey chancy and frustrating. But today Skye is no longer out of easy reach. The roads are excellent. Coaches bring streams of tourists all through the summer. There is an airfield.....
Skye is becoming a holiday island. All is changing.
Except the mountains.

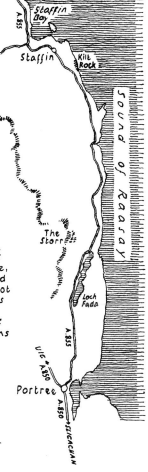

TROTTERNISH

Quiraing

Staffin Bay

Staffin

Kilt Rock

UIG

Sound of Raasay

The Storr

Loch Fada

A855

Portree

UIG A850

A850 SLIGACHAN

Public roads
The escarpment

SCALE OF MILES

0 1 2 3 4 5 6

Trotternish is the most northerly
peninsula of Skye, and along it for
fifteen miles a lofty escarpment forms
a continuous backbone of rock facing east
to the Sound of Raasay and offering a fine
high-level traverse that suffers in popularity
only because of the greater appeal of the Cuillin
away to the south but is nevertheless deserving
of a visit for its own distinctive merit.

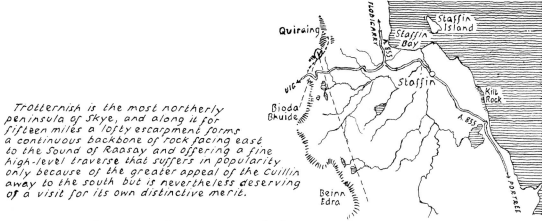

384 The hills of Trotternish

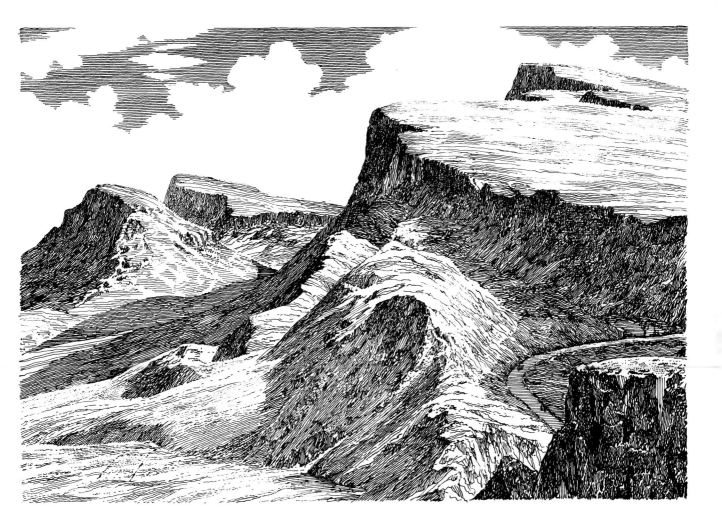

Not even the heights of the Black Cuillin can show a more
fantastic display of bizarre rocks than the Quiraing,
overlooking Staffin Bay and easily reached by a path
from the top of the road to Uig. Natural sculpturings
caused by ages of weather erosion make a unique scene
of rock architecture — an extraordinary reward for the
slight effort of visiting this remarkable place.

385 The Quiraing, 1779'

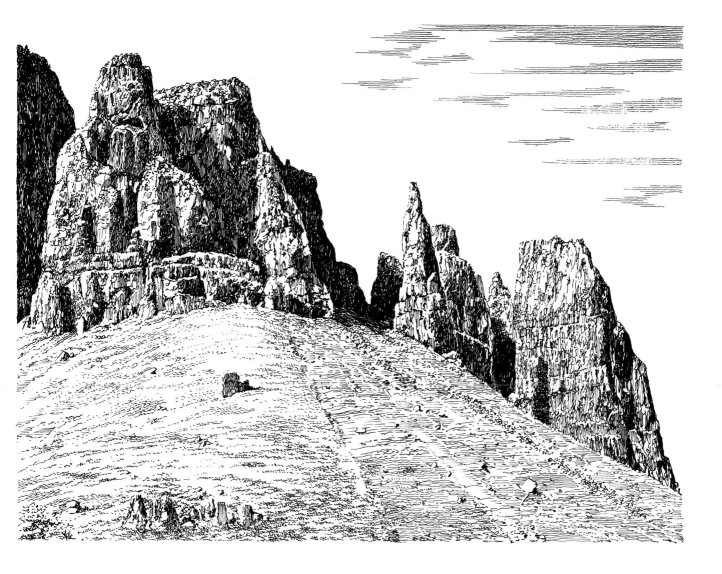

Upon reaching Loch Fada on the road journey north from Portree the near-vertical cliffs of the Storr, identifiable by the conspicuous pinnacle of the Old Man at their base, form a striking skyline ahead, and remain in view for some miles further, becoming even more impressive before receding and declining into the Trotternish escarpment.

386 The Storr, 2360′
(the steep high cliff)

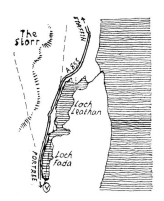

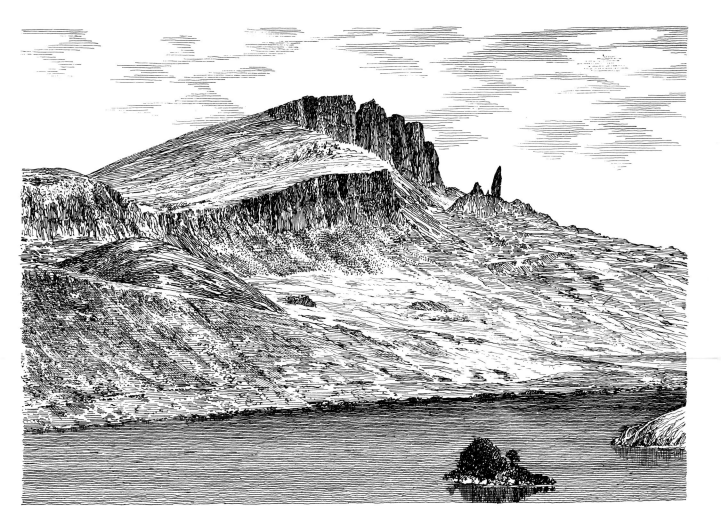

Below the precipice of the Storr and clearly seen from the road along the base of the mountain is a remarkable array of rock pinnacles that have defied destruction by the weather. Presiding over a group of lesser fry is the wellknown landmark known as the Old Man, 160 feet tall.

387 The Old Man of Storr

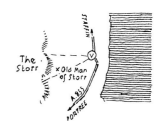

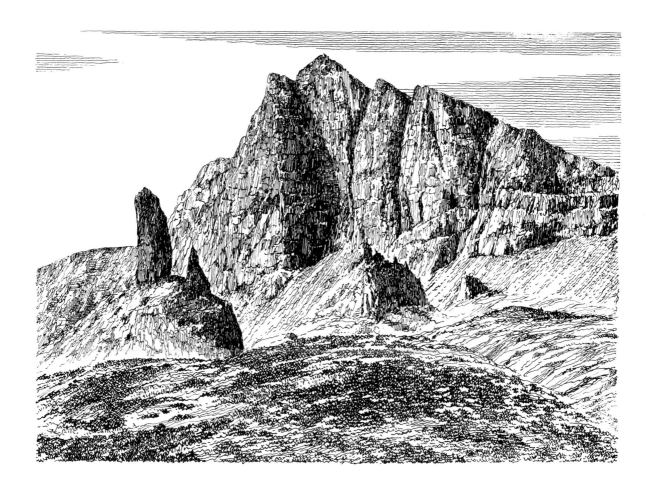

Most visitors to Skye get their first close view of the Black Cuillin upon reaching Loch Sligachan, and the scene here presented of the graceful pyramid of Sgùrr nan Gillean rising above a notched skyline is extremely impressive and a fitting introduction to the wonderful array of mountains beyond.

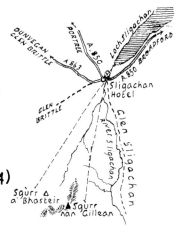

388 Sgùrr nan Gillean, 3167' (M.184)
(the peak of the young men)
and
Sgùrr a' Bhasteir, 2950'
(the peak of the executioner)

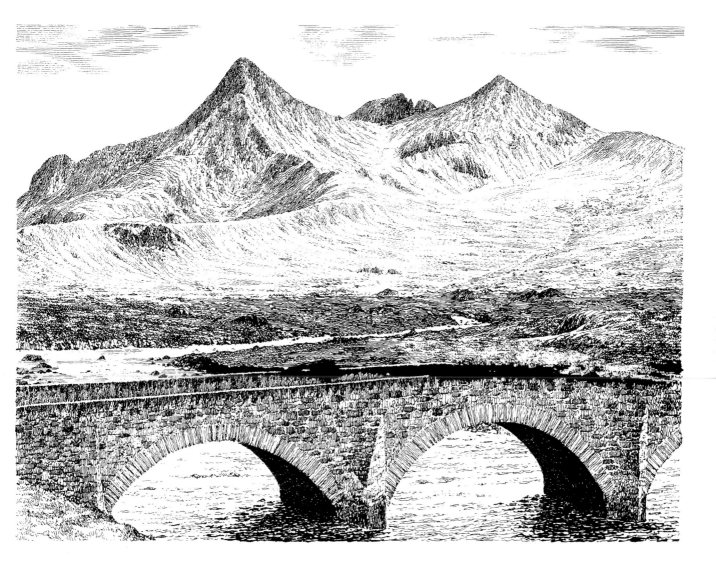

The viewpoint is Sgùrr a' Bhasteir

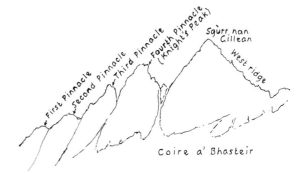

First Pinnacle
Second Pinnacle
Third Pinnacle
Fourth Pinnacle
(Knight's Peak)
Sgùrr nan Gillean
West ridge
Coire a' Bhasteir

389 Sgùrr nan Gillean: the Pinnacle Ridge

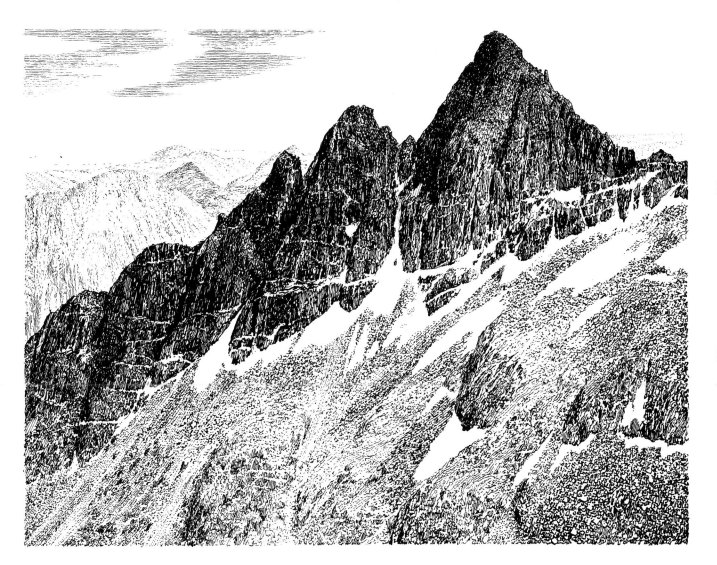

The long but simple walk along Glen Sligachan passes between mountain ramparts of imposing stature, with the serrated heights of Sgùrr nan Gillean on the west side and Marsco and Blaven towering high on the east. In particular, Sgùrr nan Gillean arrests attention throughout, its north ridge carved into a series of pinnacles and its declining south ridge interrupted by the small peak of Sgùrr Beag before falling dramatically from Sgùrr na h'Uamha to the valley.

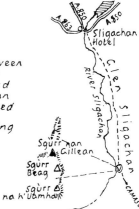

390 Sgùrr Beag, 2530'
(the little peak)
and
Sgùrr nan Gillean, 3167'

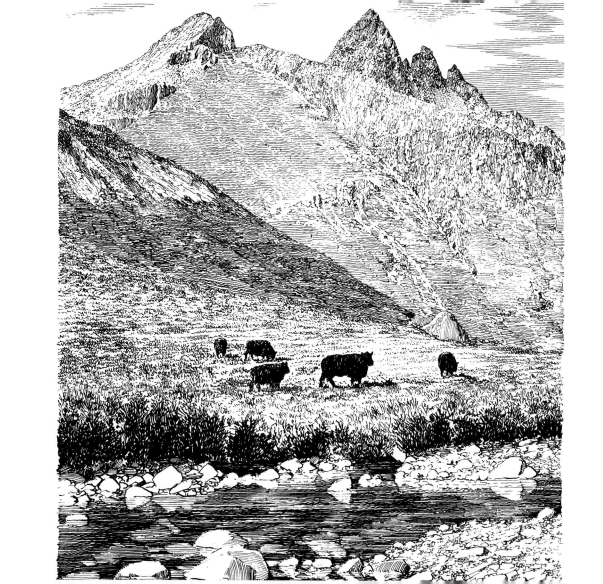

The viewpoint is Bruach na Frithe

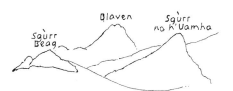

391 Sgùrr Beag, 2530'
and
Sgùrr na h-Uamha, 2420'
(the peak of the cave)

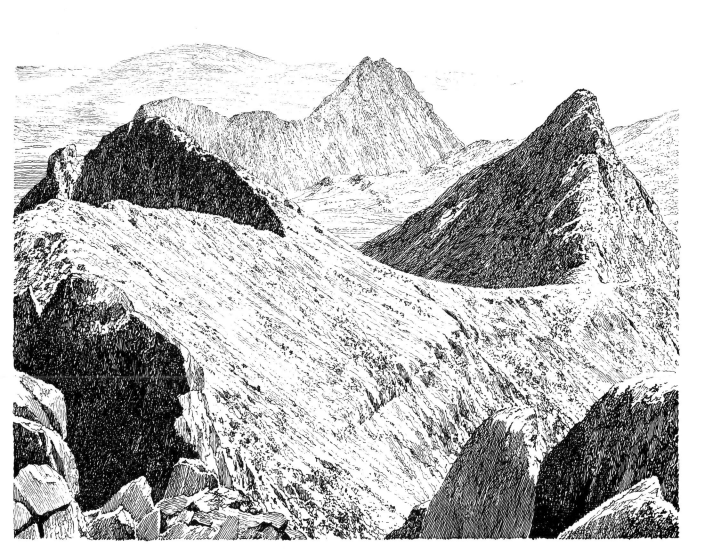

Bruach na Frithe

Sgùrr a' Fionn Choire

Am Basteir

Bealach
nan Lice

The viewpoint is the summit of Sgùrr nan Gillean
(looking down the west ridge)

Bealach a' Bhasteir

392 Bruach na Frithe, 3143' (M.191)
(the brae of the forest)

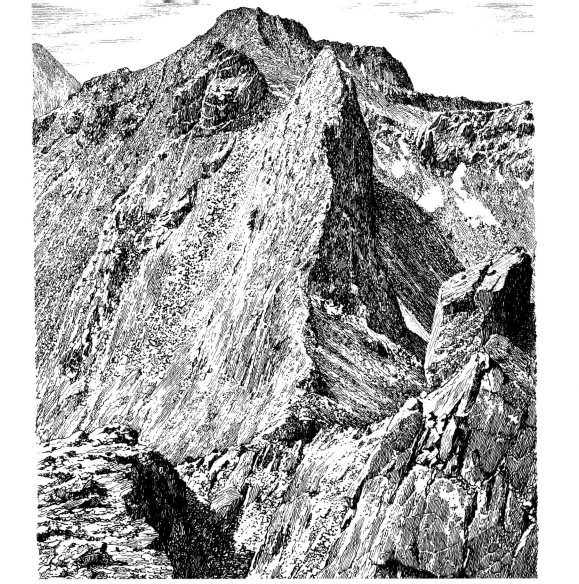

The viewpoint is the head of Fionn Choire

393 Am Basteir, 3050' (M.246)
(the executioner)

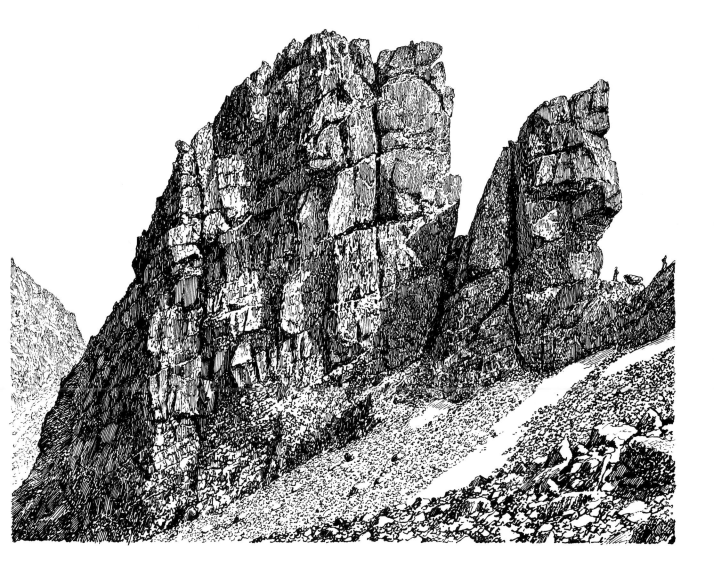

Gars-bheinn

Sgùrr Dubh
na Da Bheinn

Sgùrr
Dubh Mòr

Sgùrr
Dubh Beag

An Caisteal

The viewpoint is Bruach na Frithe

Sgùrr
na Bhairnich

Coirèa' Mhadaidh

394 The Black Cuillin (southern section, looking south)

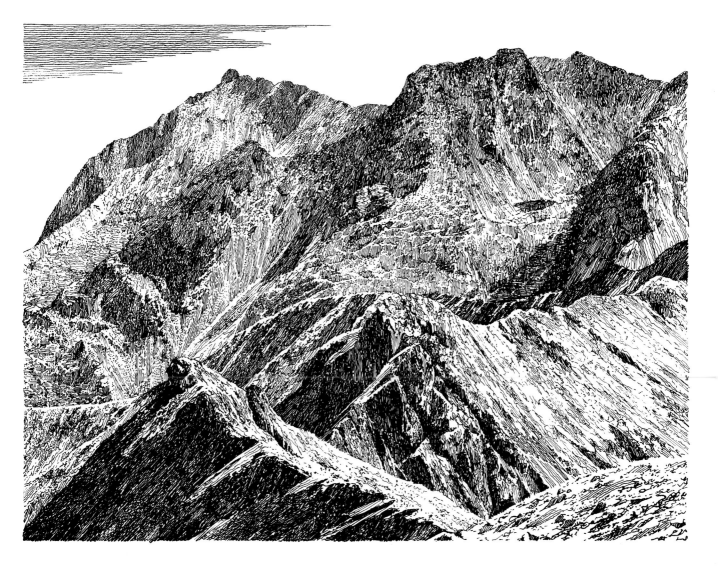

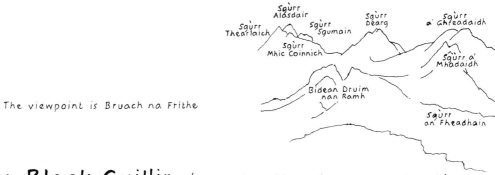

Sgùrr
Alasdair

Sgùrr
Theàrlaich

Sgùrr
Sgumain

Sgùrr
Dearg

Sgùrr
a' Ghreadaidh

Sgùrr
Mhic Coinnich

Sgùrr a'
Mhadaidh

Bidean Druim
nan Ramh

Sgùrr
an Fheadhain

The viewpoint is Bruach na Frithe

395 The Black Cuillin (central section, looking southwest)

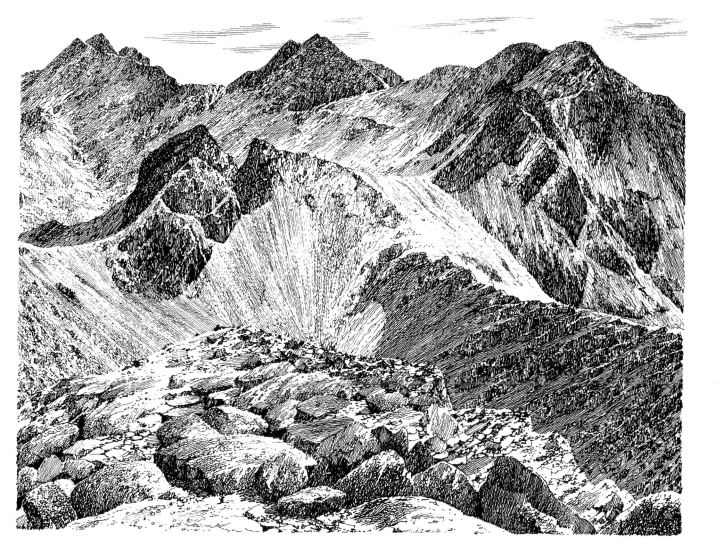

The viewpoint is the road between
Glen Brittle and Carbost

Bruach
na Frithe

An Caisteal

Bidein Druim
nan Ramh

Sgùrr a'
MhadaidhSgùrr
Thuilm

Sgùrr
an
Fheadain

Coire na Creiche

396 Coire na Creiche

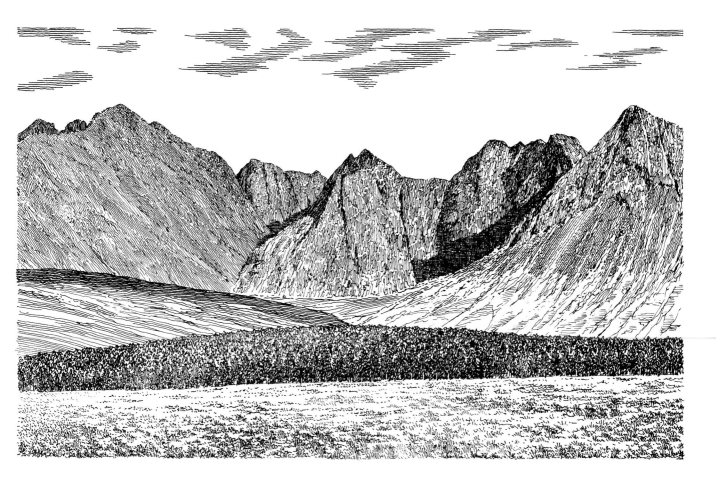

Bidein Druim
nan Ramh

Bealach
na Glaic
Moire

Sgùrr a' Mhadaidh

Sgùrr
an
Fheadain

Coire na Creiche

The viewpoint is the northwest
ridge of Bruach na Frithe

397 Bidein Druim nan Ramh, 2850'
(the peaks of the ridge of oars)
and
Sgùrr a' Mhadaidh, 3014' (M.270)
(the foxes' peak)

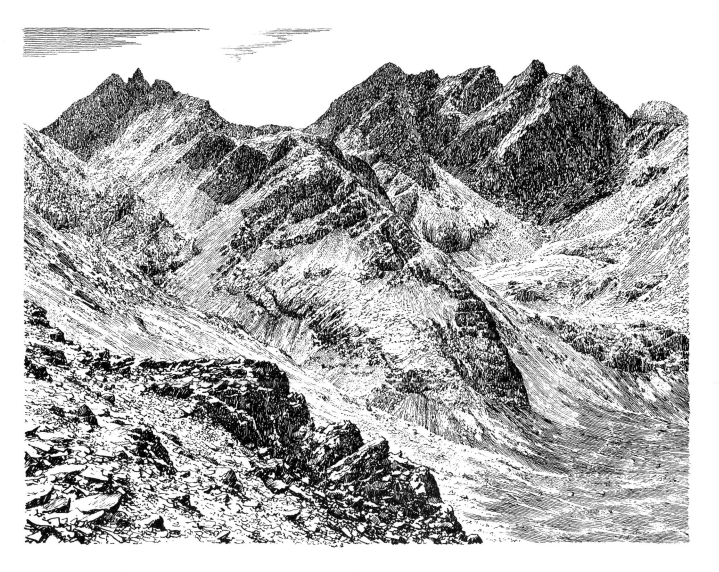

The viewpoint is the road
in Glen Brittle near the Youth Hostel

Sgùrr a' Mhadaidh

Sgùrr a' Ghreadaidh

An Diallaid

Sgùrr na Banachdich

Coir' an Eich

Sgùrr nan Gobhar

Coire a' Ghreadaidh

398 Coire a' Ghreadaidh

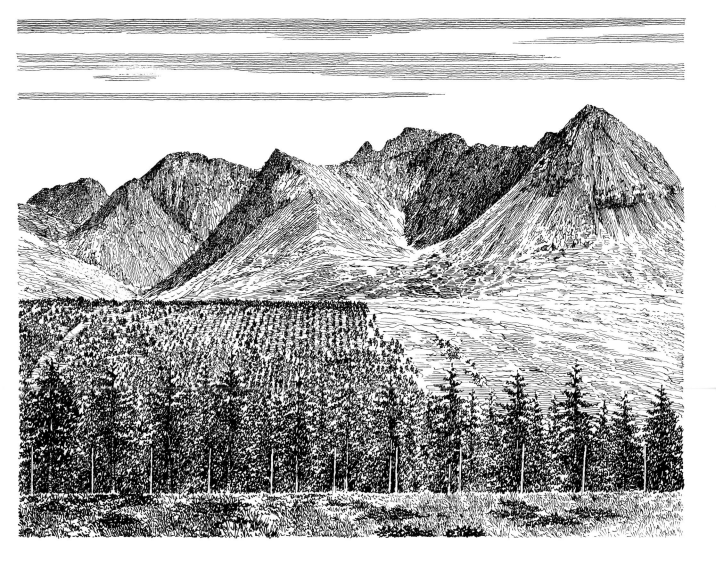

The viewpoint is the summit of Sgùrr na Banachdich

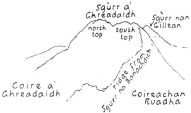

399 Sgùrr a' Ghreadaidh, 3197´ (M.173)
(the peak of the mighty winds)

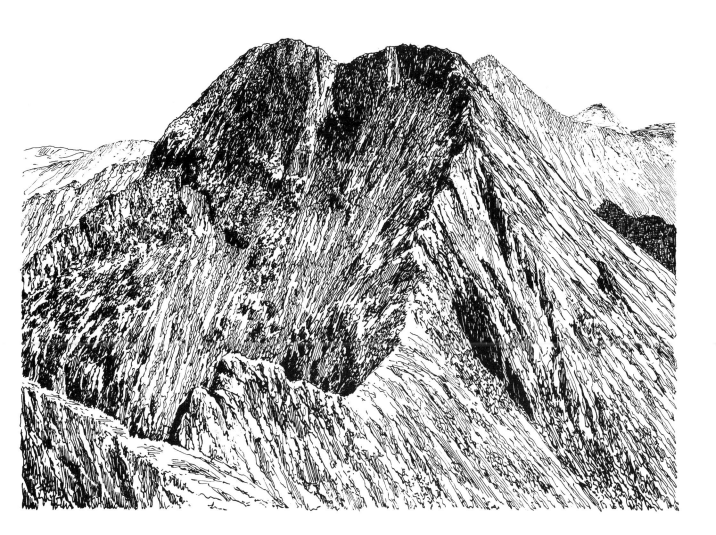

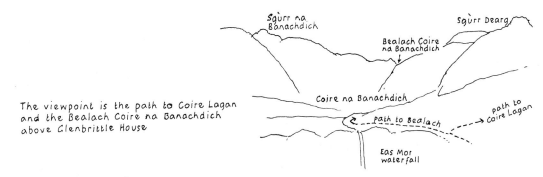

Sgùrr na Banachdich

Sgùrr Dearg

Bealach Coire na Banachdich

Coire na Banachdich

The viewpoint is the path to Coire Lagan and the Bealach Coire na Banachdich above Glenbrittle House

Path to Bealach

path to Coire Lagan

Eas Mor waterfall

400 Coire na Banachdich

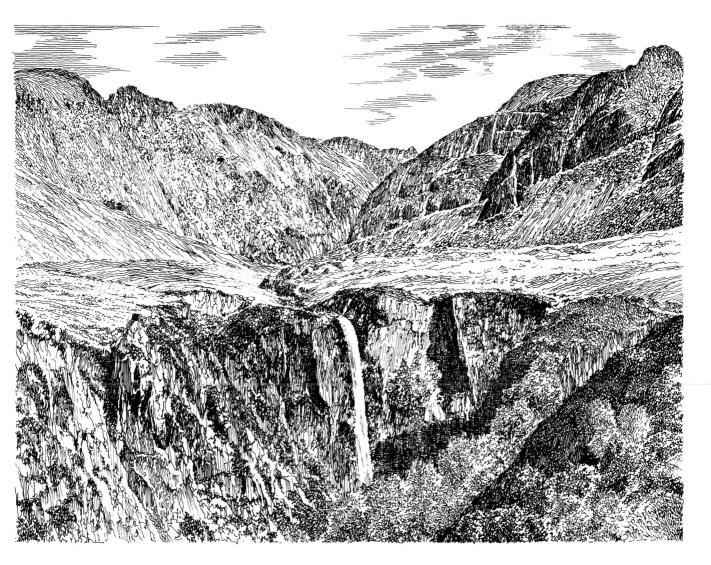

Sgùrr
nan Gobhar

Sgùrr na Banachdich

Coire na
Banachdich

The viewpoint is the camp site
at the head of Loch Brittle

401 Sgùrr na Banachdich, 3167′ (M.185)
(the smallpox peak)

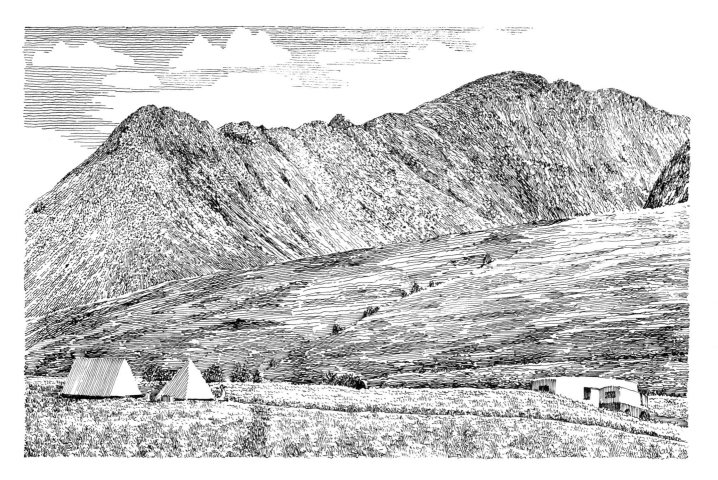

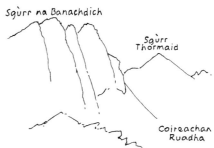

Sgùrr na Banachdich

Sgùrr
Thormaid

Coireachan
Ruadha

The viewpoint is Sron Bhuidhe

402 Sgùrr na Banachdich: the east face

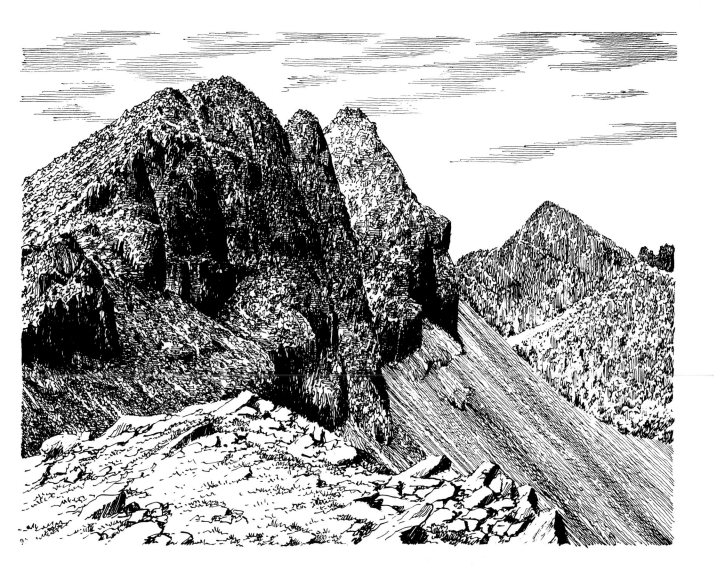

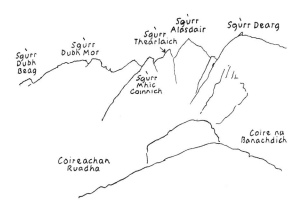

Sgùrr
Dubh
Beag

Sgùrr
Dubh Mor

Sgùrr
Thearlaich

Sgùrr
M'hic
Coinnich

Sgùrr
Alasdair

Sgùrr Dearg

Coireachan
Ruadha

Coire na
Banachdich

The viewpoint is the summit
of Sgùrr na Banachdich

403 The Black Cuillin (southern section, looking southeast)

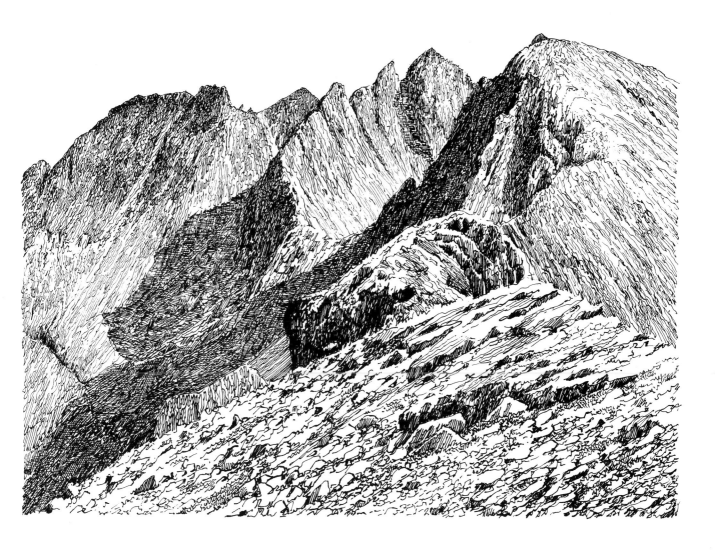

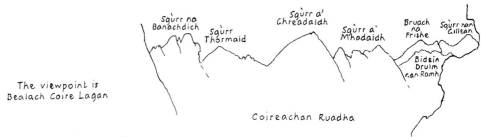

Sgùrr na Banachdich

Sgùrr Thormaid

Sgùrr a' Chreadaidh

Sgùrr a' Mhadaidh

Bruach na Frithe

Sgùrr nan Gillean

Bidein Druim nan Ramh

The viewpoint is Bealach Coire Lagan

Coireachan Ruadha

404 The Black Cuillin (central section, looking north)

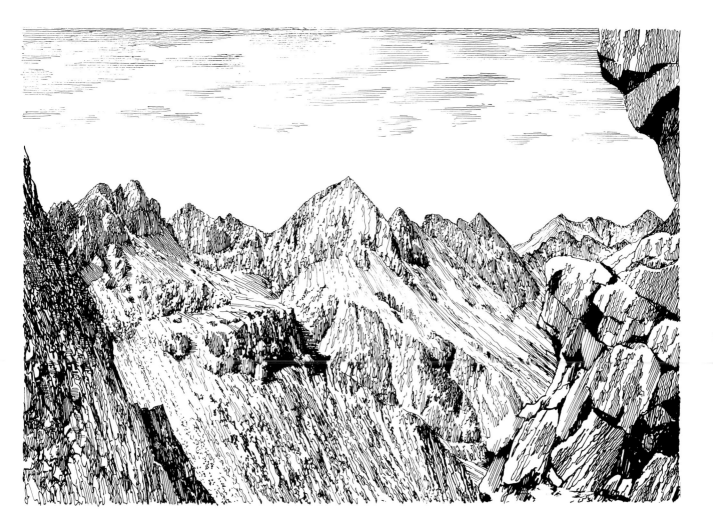

Acknowledgments are due to
Mr Mark B. Richards for the
loan of his photographs
of the Sgùrr Dearg area.

The viewpoint is the road
in Glen Brittle near the Youth Hostel

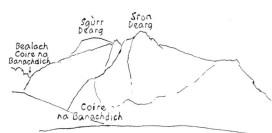

405 Sgùrr Dearg, 3254' (M.147)
(the red peak)

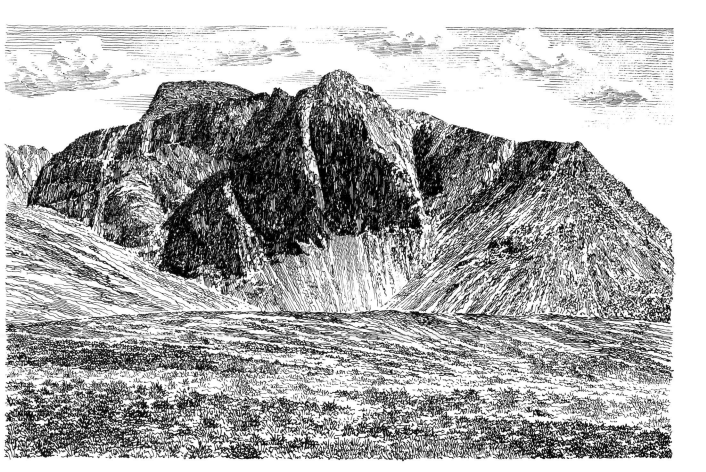

The summit-plateau of Sgùrr Dearg is overtopped 20 feet by a spectacular pinnacle of rock rising from the stony slope only a few yards away, the crest of the pinnacle therefore being the highest point of the mountain and properly the true summit—the most difficult of all Munros to attain. The pinnacle was first climbed in 1880: it is no longer inaccessible but remains a preserve of cragsmen only. It is out of reach of ordinary mortals.

406 Sgùrr Dearg: the Inaccessible Pinnacle

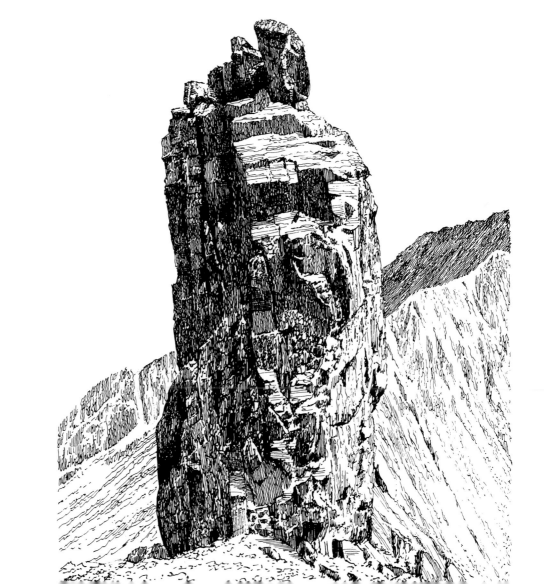

The Inaccessible Pinnacle takes the form of a narrow arete on its east side, descending towards the Bealach Coire Lagan; beyond its foot the fall to the bealach is further interrupted by a much sturdier tower of rock, An Stac, both obstacles being avoidable by walkers who keep to the scree alongside.

407 Sgùrr Dearg : An Stac, 3125' (the stack)

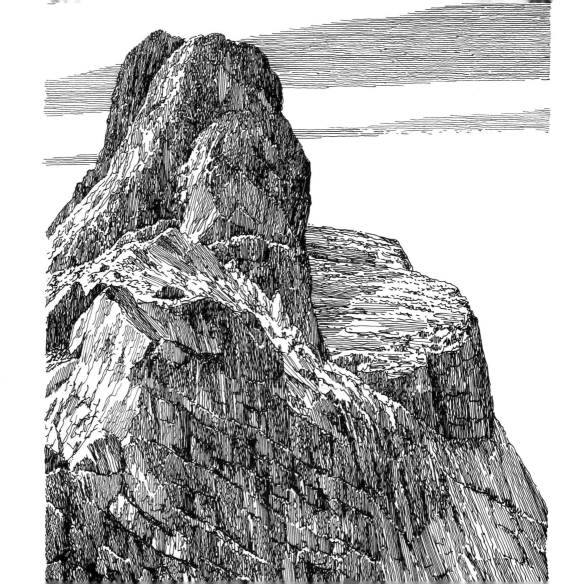

The viewpoint is Coire Lagan
south of Loch an Fhir-bhallaich

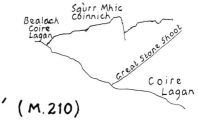

408 Sgùrr Mhic Coinnich, 3107´ (M.210)
(Mackenzie's peak)

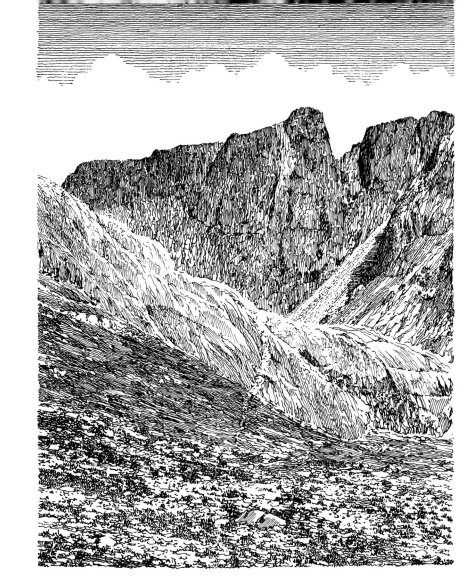

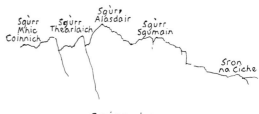

Sgùrr M'hic Coinnich

Sgùrr Thearlaich

Sgùrr Alasdair

Sgùrr Sgumain

Sron na Ciche

The viewpoint is
Bealach Coire Lagan

Coire Lagan

409 The Sgùrr Alasdair group

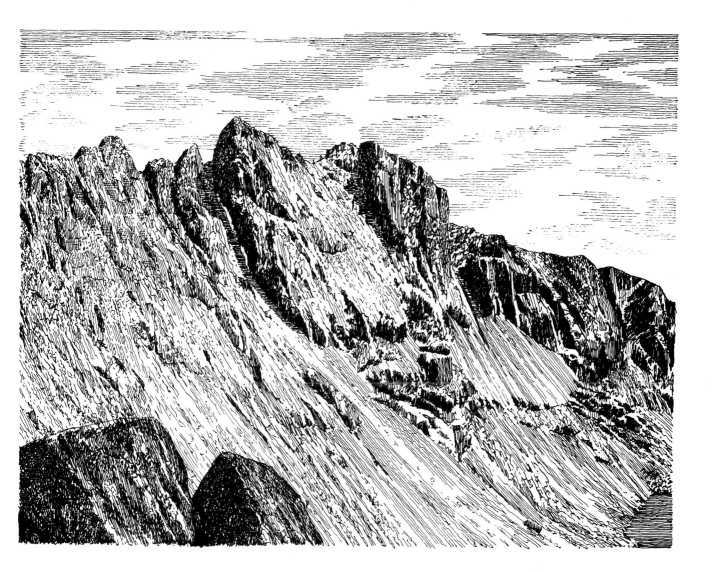

Sgùrr
Mhic Coinnich

Sgùrr
Alasdair

Sgùrr
Sgumain

The viewpoint is
Loch an Fhir-bhallaich

Coire Lagan

410 **Sgùrr Alasdair, 3309′ (M.117)**
and (the peak of Alexander)
Sgùrr Sgumain, 3104′
(Sgùrr Squmain) (the stack peak)

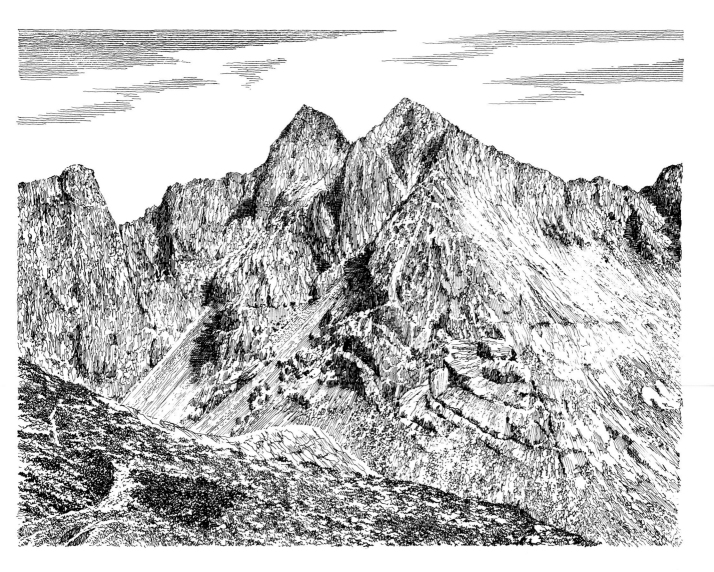

The viewpoint is Coire Lagan
south of Loch an Fhir-bhallaich

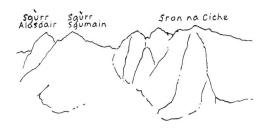

Coire Lagan

411 Coire Lagan

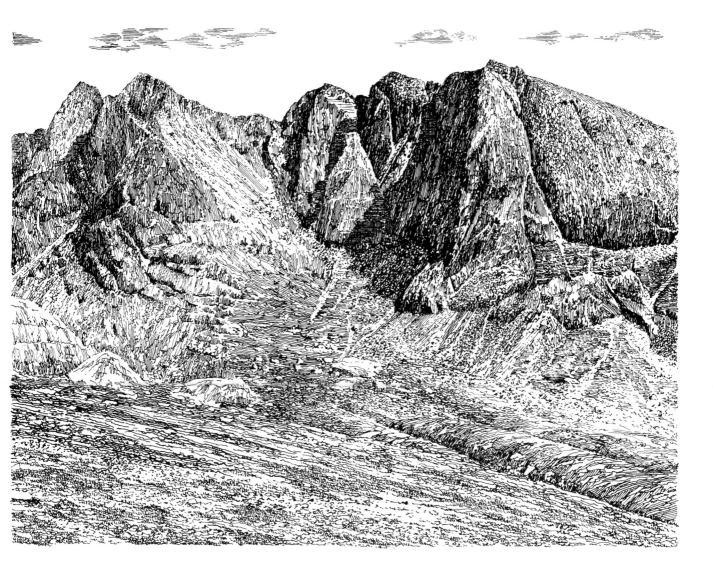

The viewpoint is the monument
on the north ridge of Sgurr na Stri.

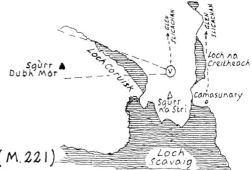

412 Sgùrr Dubh Mor, 3089′ (M.221)
(the big black peak)

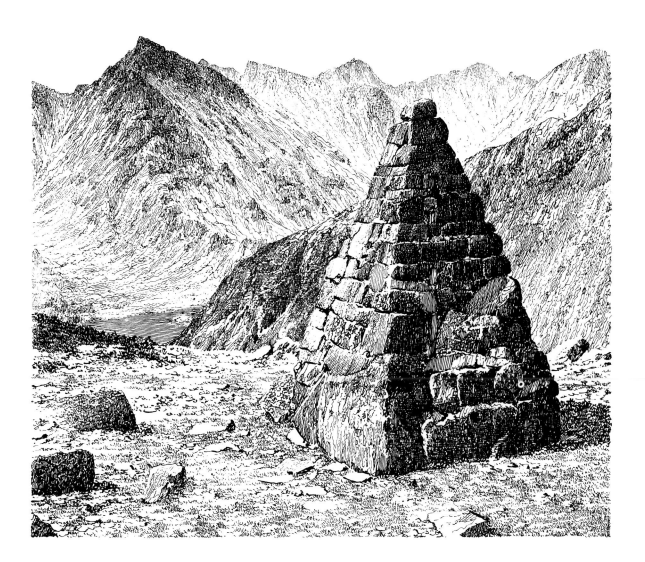

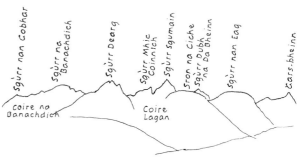

The viewpoint is the
coastal path on the
east side of Loch Brittle

413 The Black Cuillin (southern section, looking northeast)

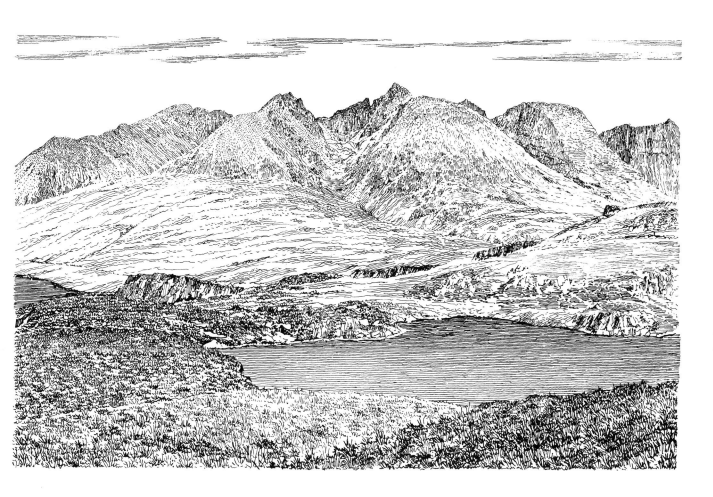

The coastal path alongside Loch Brittle provides,
at its highest point, a memorable view of the
southern part of the Cuillin range, the nearer
heights of Sgùrr nan Eag and Gars-bheinn
being well seen at its termination.

414 Sgùrr nan Eag, 3037'
(the notched peak) (M.255)
and
Gars-bheinn, 2934'
(the echoing mountain)

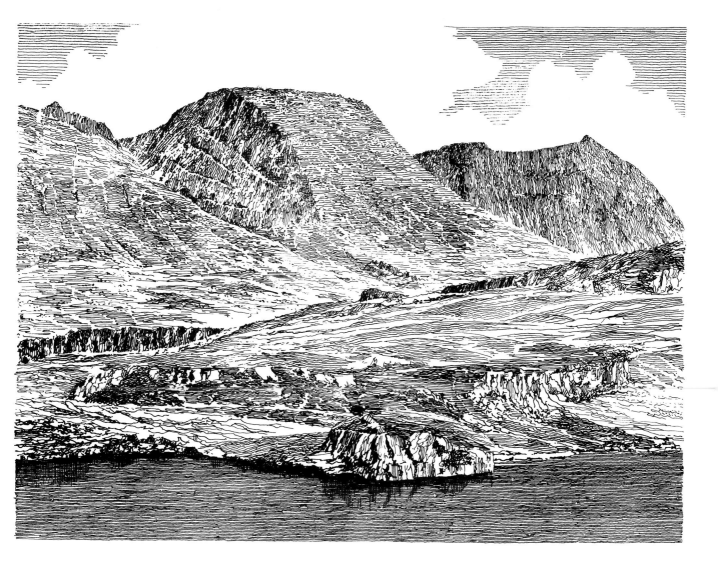

Travellers along the road to Elgol from Broadford are confronted at Torrin by an arresting view across Loch Slapin to the rocky turrets of Blaven and Clach Glas, together forming a great rampart across the western sky.

415 Blaven, 3042' (M. 250)
(the hill of bloom)
and
Clach Glas, 2590'
(the grey stone)

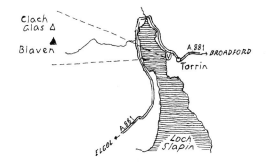

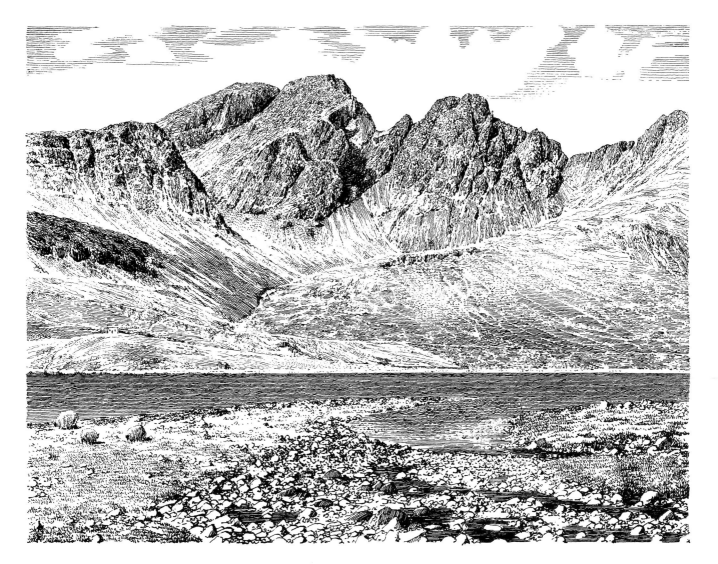

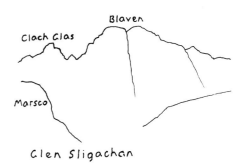

The viewpoint is Sgùrr nan Gillean

416 Glen Sligachan and Blaven

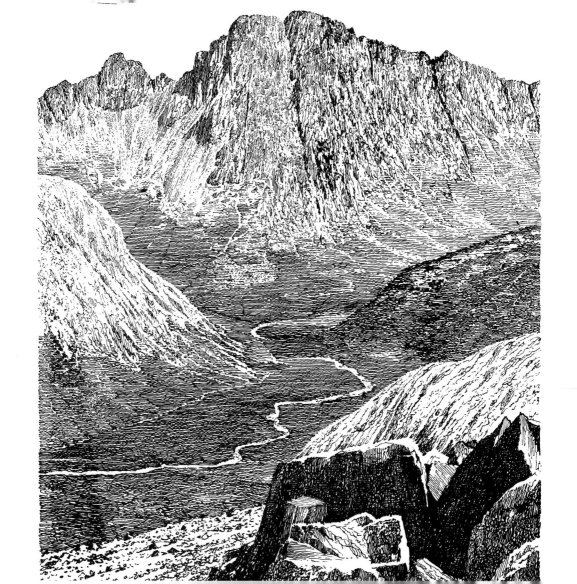

Clach
Glas

Blaven

Sgùrr na Stri

Loch Coruisk

The viewpoint is Sgùrr na Banachdich

417 Blaven and Loch Coruisk

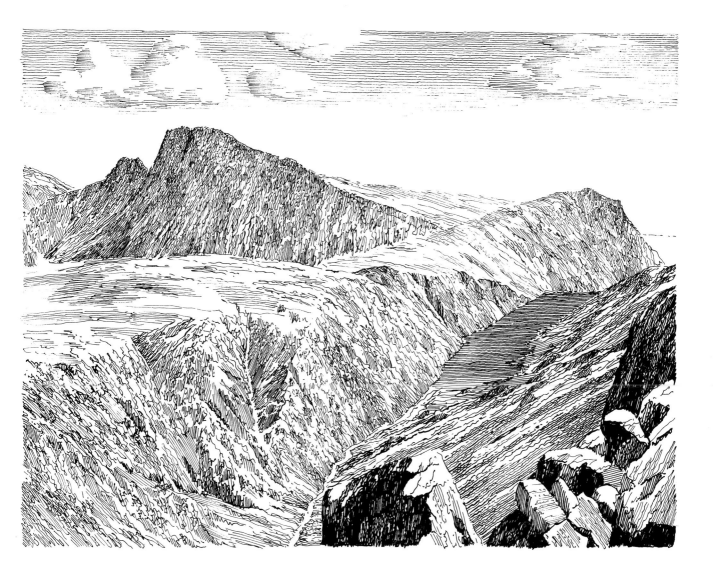

The viewpoint is the shore
of Loch Scavaig near Elgol

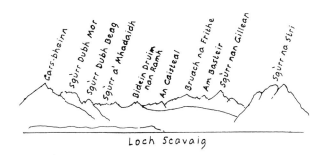

Garsbheinn
Sgùrr Dubh Mor
Sgùrr Dubh Beag
Sgùrr a' Mhadaidh
Bidein Druim nan Ramh
An Caisteal
Bruach na Frithe
Am Basteir
Sgùrr nan Gillean
Sgùrr na Stri

Loch Scavaig

418 The Black Cuillin, from Elgol

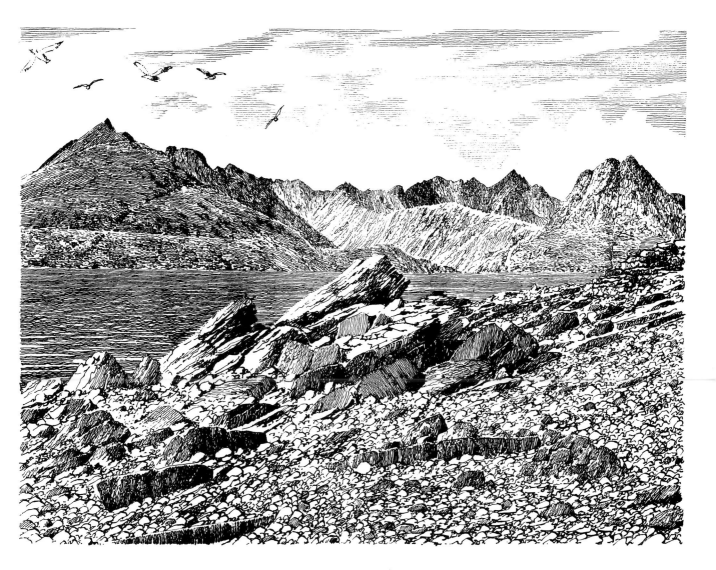

The view of the Cuillin from
Elgol is an acknowledged
classic, often described
as the finest prospect in
the British Isles, and the
more distant view from
Ord is little inferior
although less intimate,
its quality enhanced by
a colourful foreshore,
by the inclusion of
Blaven in the scene,
and by the absence
of the hordes of
visitors that rob
Elgol of its peace
and quiet.

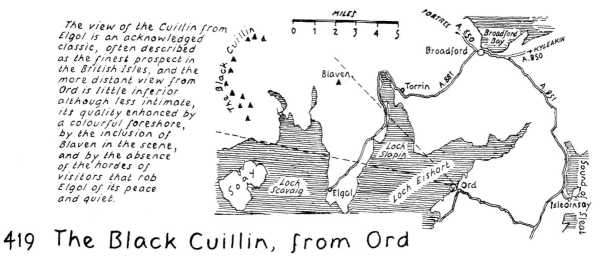

419 The Black Cuillin, from Ord

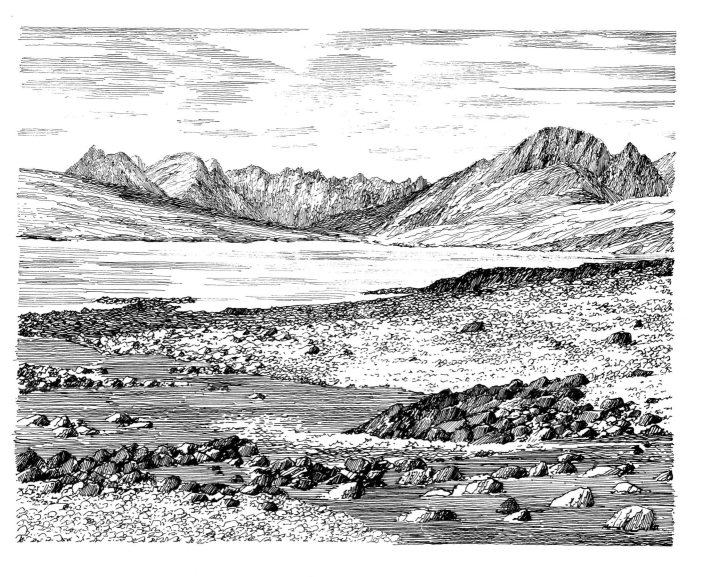

Marsco is the most westerly of the Red Hills and is very conspicuous in views from the vicinity of the Sligachan Hotel. A much-trodden path along Glen Sligachan skirts its base and leads through the hills to emerge on the shore of Loch Scavaig, a branch crossing a ridge to reach Loch Coruisk.

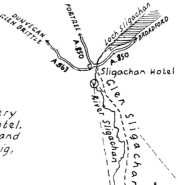

420 Marsco, 2414'

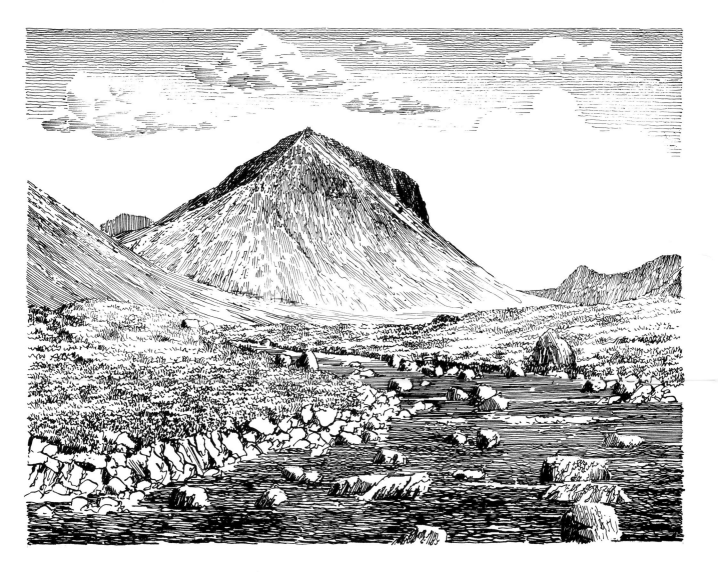

As the road A.850 curves in a graceful loop around the head of Loch Ainort a splendid view is revealed of the two fine peaks of Belig and Garbh-bheinn, their full height displayed over a foreground of cascading streams. Garbh-bheinn is the northern outpost of the Blaven range.

421 Belig, 2250'
and
Garbh-bheinn, 2649'
(the rough mountain)

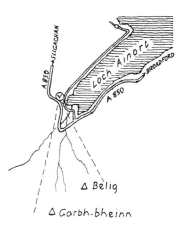

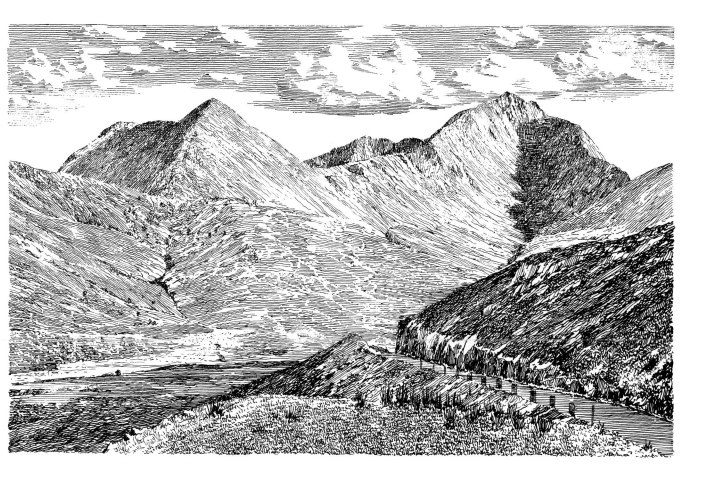

It is not unusual in Scotland for different mountains to share the same name, and this is confusing when they are in proximity. The first two mountains seen at close range by travellers into Skye from Kyle of Lochalsh are both named Beinn na Caillich. According to legend, on the summit of the one overlooking Broadford is interred the body of a Norse princess.

422 Beinn na Caillich, 2403'

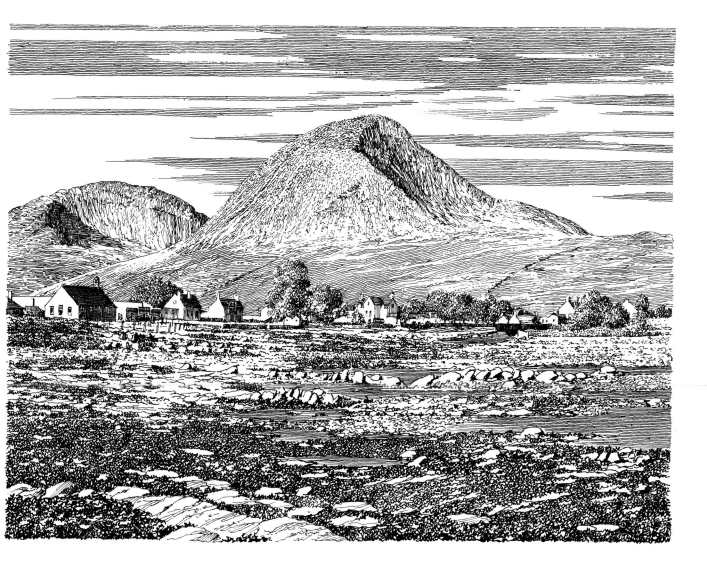

The first sight of Skye
on the popular approach
via Glen Shiel is the
prominent height of
Beinn na Caillich,
occupying a promontory
overlooking the Kyleakin
ferry and separated from
the mainland by the narrow
strait of Kyle Rhea.

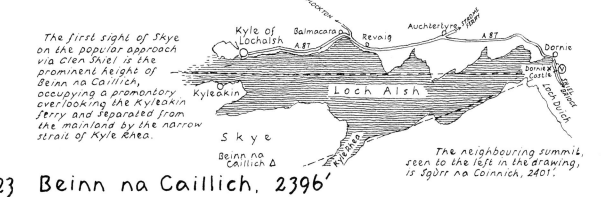

The neighbouring summit,
seen to the left in the drawing,
is Sgùrr na Coinnich, 2401'.

423 Beinn na Caillich, 2396'

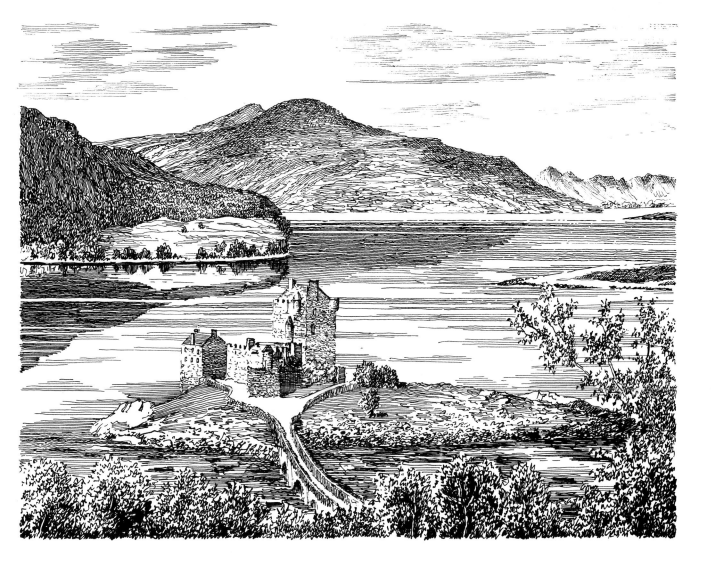

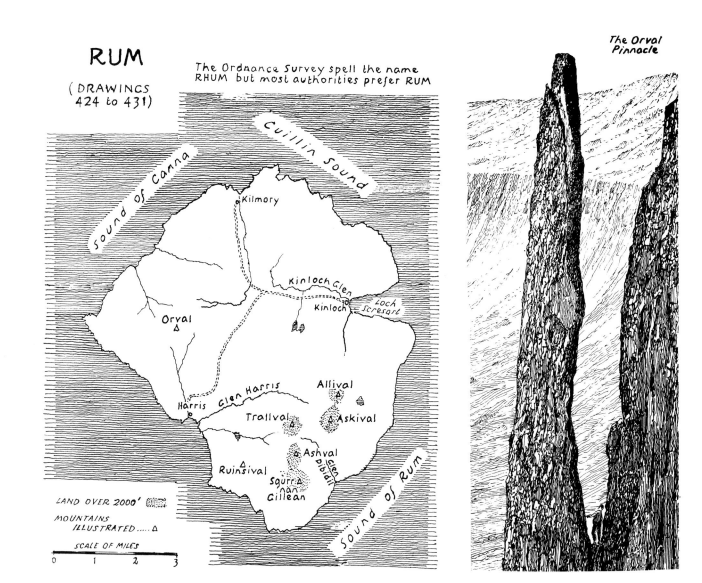

RUM

(DRAWINGS 424 to 431)

The Ordnance Survey spell the name RHUM but most authorities prefer RUM

Sound of Canna

Cuillin Sound

Kilmory

Kinloch Glen

Kinloch — Loch Scresort

Orval △

Allival △

Glen Harris

Trallval △

Harris

Askival △

Ashval △

Ruinsival △

Glen Dibidh

Sgurr nan Gillean △

Sound of Rum

LAND OVER 2000' ▨

MOUNTAINS ILLUSTRATED △

SCALE OF MILES

0 1 2 3

The Orval Pinnacle

The natural attractions of Rum are given no official publicity: there are no holiday brochures describing the charms of the island and no warm invitation to tourists; there are no hotels, no bed and breakfast signs, no caravan sites. It has always been so. Rum was privately owned until 1957, when it was bought for biological research by the Nature Conservancy, who have continued a policy of exclusion. Visitors are not encouraged, nor catered for. Permission to stay on the island must be obtained in advance from the Conservancy and is usually granted, subject to conditions, to applicants who wish to climb the mountains and will make no demands on local services and supplies.

The appeal of the mountains is enhanced by their isolation and privacy, and conditions are primeval. There are no chair-lifts, no car-parks, no picnic areas, no well-trodden tracks, no rescue posts, no litter. These are mountains that have never been despoiled; only summit cairns tell that others have been here before. They form a splendid group in the southeastern corner of the island, towering up steeply above a rugged coast. They are known collectively as the Cuillin of Rum, each having a distinctively individual character and all being rough, craggy and boulder-strewn, although falling far short of the Cuillin of Skye both in altitude and difficulty. The five principal heights are linked by bealachs and together give a hard day's traverse of great merit.

The pier at which boats call from Mallaig, the usual route of approach from the mainland, is at Kinloch, where there is a small community concerned mainly with the administration of the island. From here the only road crosses the interior to the remote outpost of Harris, with a branch turning north to lonely Kilmory.

The writer, having reached an age when he was not prepared to suffer the privations of a stay on Rum, prevailed upon a young friend, Mr David Pugh, to go as proxy, and the drawings and descriptions in this chapter are based on his photographs and notes, with grateful thanks.

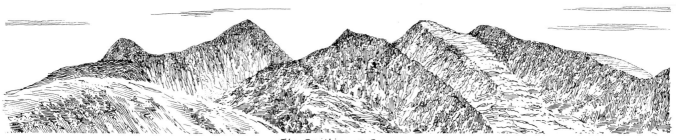

The Cuillin of Rum

Rum is clearly in view from many parts of the mainland between Ardnamurchan and Knoydart, its outline appearing as a dreamily mystical silhouette across a great expanse of the western sea and becoming starkly distinct against a setting sun. The viewpoint of the drawing is a headland near Morar, sixteen miles distant.

424 The Island of Rum, from the mainland

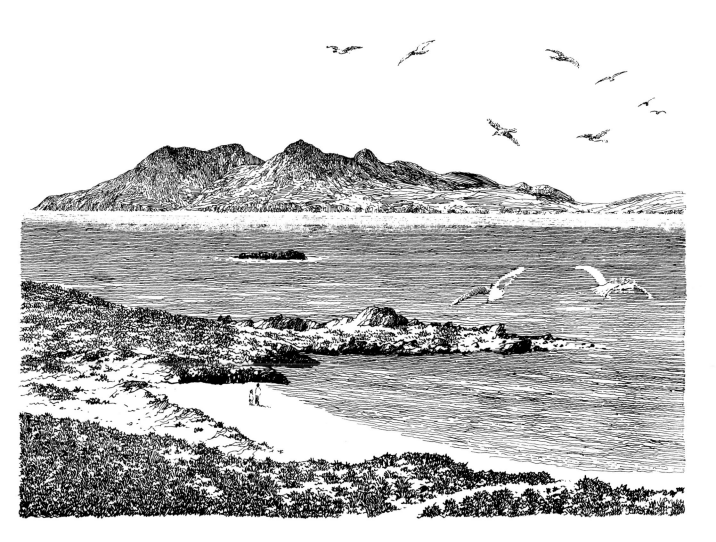

Orval is set apart from its fellows across Glen Harris and overlooks the massive sea cliffs of the west coast. Its main feature is a long escarpment of basalt from the base of which rises a remarkably slender pinnacle a hundred feet high.

425 Orval, 1869'

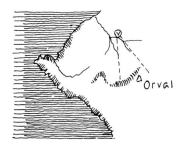

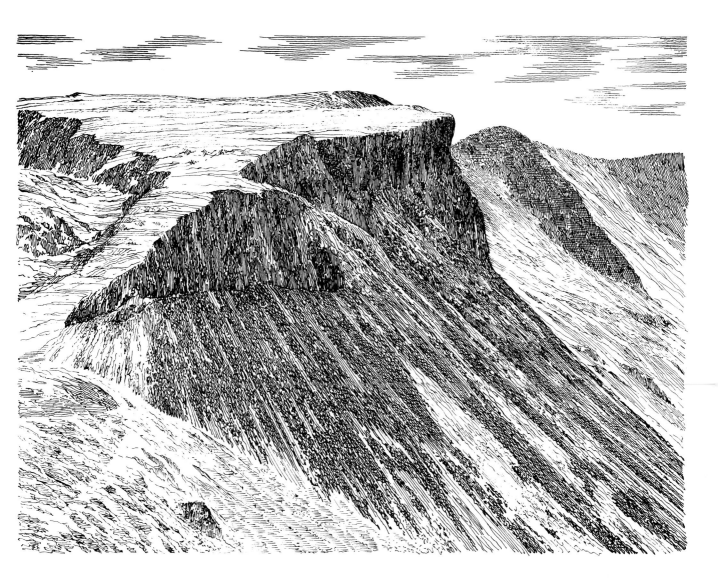

Allival is the mountain nearest to Kinloch, from where it appears as a graceful peak. It is the northern end of the ridge traverse and is usually ascended from the Dibidil path. The summit cap is of tiered rocks and there are stratified crags elsewhere of unusual geological interest. Here occurs a variety of gabbro known as allivalite (named after the mountain).

426 Allival, 2365'

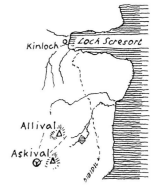

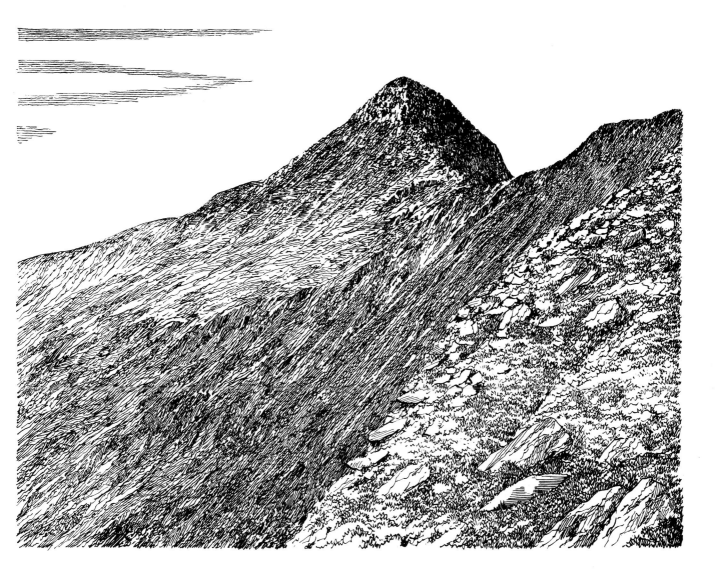

Askival is the highest of the Cuillin of Rum and its rough top is usually reached on the traverse from Allival, the connecting ridge being a rocky scramble of increasing difficulty over ground pitted with the burrows of Manx shearwaters. The summit has an Ordnance Survey column and a circular windshelter. Askival's many crags provide the main rock-climbing routes on the island. The west ridge, continuing the traverse, descends steeply to the Bealach an Oir.

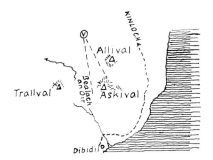

427 Askival, 2659'

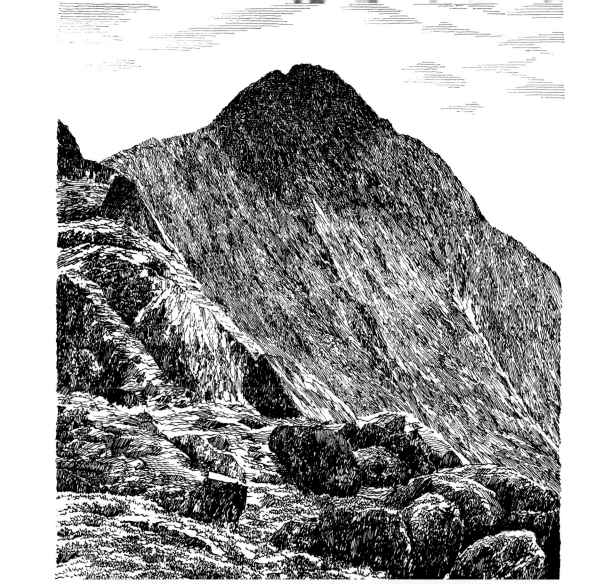

From Askival the main ridge turns west, crossing the Bealach an Oir and rising steeply to the double summit of Trallval, the highest point being a very sharp peak. Trallval, like others in the group, has various spellings of its name. The mountain names used in this chapter are adopted from the Scottish Mountaineering Club guide: 'The Islands of Scotland.'

428 Ruinsival, 1607' and Trallval, 2300'

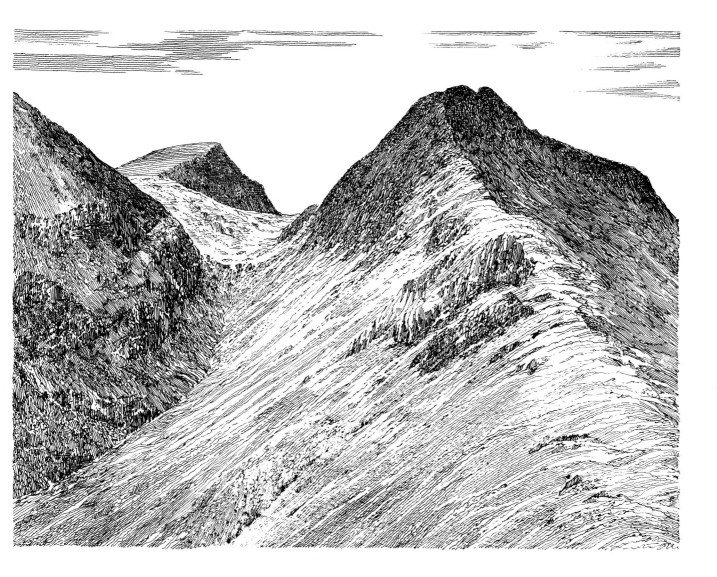

Ashval, reached from Trallval across the Bealach
an Fhuarain, is of intimidating appearance, and the
passage encounters rockfaces that can be avoided
only with difficulty. The east flank is also rough.
Beyond the summit the ridge continues south
more easily to Sgùrr nan Gillean.

429 Ashval, 2552'

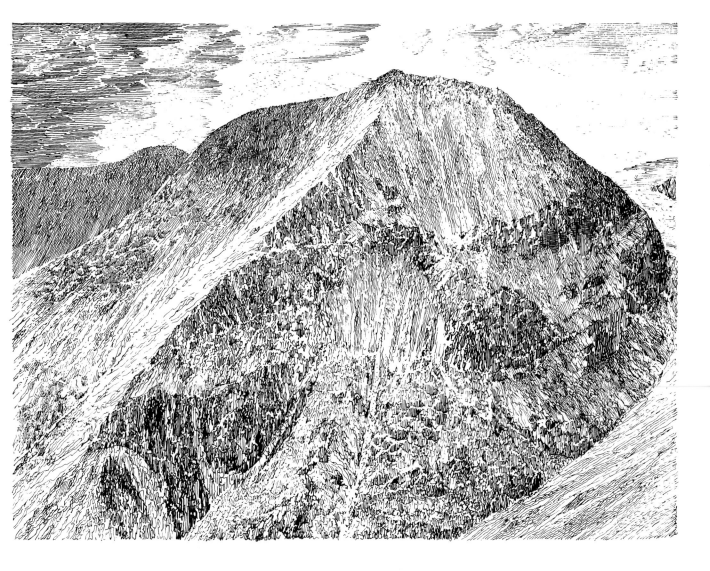

Sgùrr nan Gillean is the southern terminus of the main ridge.
The easiest line of descent is due south to the coastal path,
the east face falling into the craggy depths of Glen Dibidil
being too steep for comfort. Dibidil is a renovated bothy,
open for casual overnight shelter. Its surroundings are
magnificently wild — eagle country!

430 Sgùrr nan Gillean, 2503'

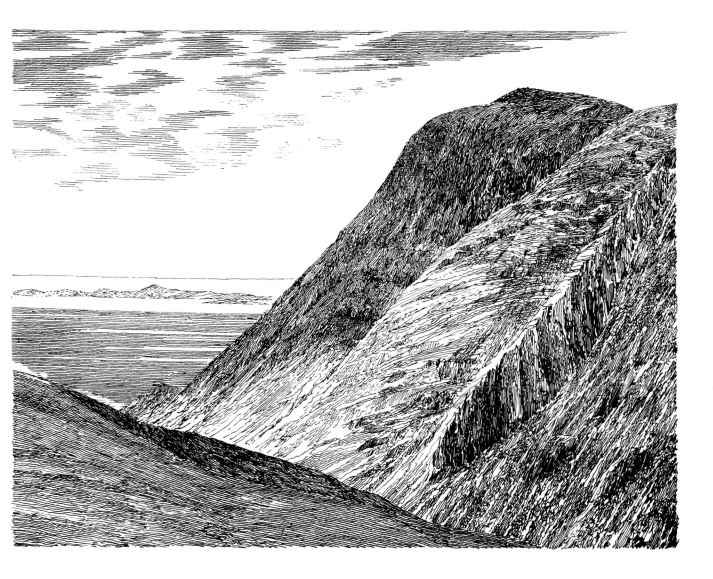

The viewpoint is the bealach
between Barkeval and Allival

Sgùrr
nan Gillean

Ashval

Trallval

west ridge
of Askival

Bealach an Oir

431 The Cuillin Ridge, west section

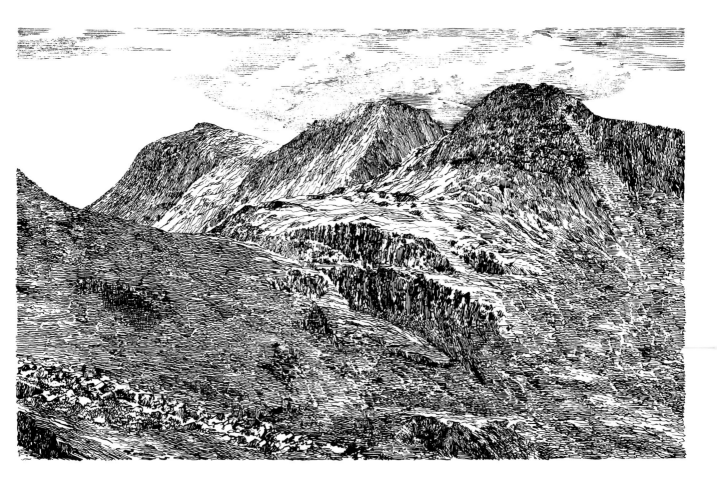

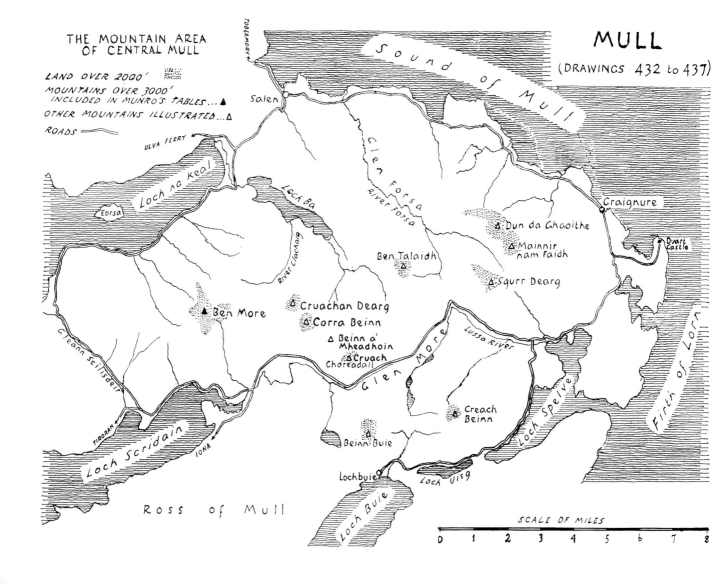

THE MOUNTAIN AREA
OF CENTRAL MULL

MULL
(DRAWINGS 432 to 437)

LAND OVER 2000'
MOUNTAINS OVER 3000'
INCLUDED IN MUNRO'S TABLES...▲
OTHER MOUNTAINS ILLUSTRATED...△
ROADS

TOBERMORY

Sound of Mull

Salen

Glen Forsa

River Forsa

Craignure

Duart Castle

ULVA FERRY

Loch na Keal

Loch Ba

Eorsa

River Clachaig

△ Dun da Ghaoithe

△ Mainnir nam Faidh

Ben Talaidh

△ Sgurr Dearg

△ Cruachan Dearg

△ Corra Beinn

▲ Ben More

△ Beinn a' Mheadhoin

△ Cruach Choireadail

Glen More

Lussa River

Firth of Lorn

Gleann Seilisdeir

Creach Beinn

Loch Spelve

TIRORAN

IONA

Loch Scridain

△ Beinn Buie

Lochbuie

Loch Uisg

Loch Buie

Ross of Mull

SCALE OF MILES

0 1 2 3 4 5 6 7 8

Mull is regarded by many tourists as an unavoidable stepping-stone to Iona, as a sprawling island that must necessarily be crossed or circumvented as a preliminary to reaching the hallowed ground of the Holy Isle. Such pilgrims would do well to tarry on their journey and seek out and enjoy the secular attractions of Mull, for this is an island of infinite delight, of scenery of a high order, rich in variety, with a spectacular coastline and a range of shapely mountains. Iona is a place to visit once, Mull often. Mull vies with Arran as scenically the most pleasing of the Inner Hebrides.

The mountains occupy a large tract in the main body of the island, the limbs radiating therefrom being hilly without forming defined peaks. Ben More is the best known and has the distinction of being the only mountain over 3000' in the Hebrides outside Skye. From its fine summit other considerable heights extend eastwards to the Firth of Lorn, culminating in a lofty upland above Craignure and adding impressiveness to the approach by sea. Surrounding roads give access to the mountains.

Mull, apart from the highway to Iona, has not yet suffered the disturbances that each summer afflict Skye and Islay and Arran, and is seemingly content to remain as a lonely outpost defended by its wide moat of sea. There are hotels at Tobermory, the most attractive coastal town in the Western Isles, and at Salen and Craignure, but accommodation for visitors is very sparse or non-existent in the remoter parts although there is an increase in provision for travellers on the road to Iona. Time will inevitably bring a greater degree of commercialisation — significantly the main roads are being improved, and new forests are appearing — but nothing can rob the island of the charm of its lovely landscapes and seascapes. Mull is for ever.

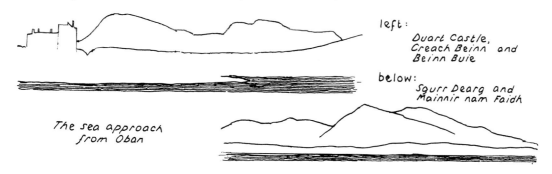

left:
Duart Castle,
Creach Beinn and
Beinn Buie

below:
Sgurr Dearg and
Mainnir nam Faidh

The sea approach
from Oban

Ben More is the supreme mountain of Mull, overtopping all others and seemingly proud of its distinction as the only Munro in the islands south of Skye. Fittingly it is a fine peak, seen to advantage from west and south, and the ascent becomes a matter of honour for all active sojourners on Mull.

432 Ben More, 3169' (M.182)

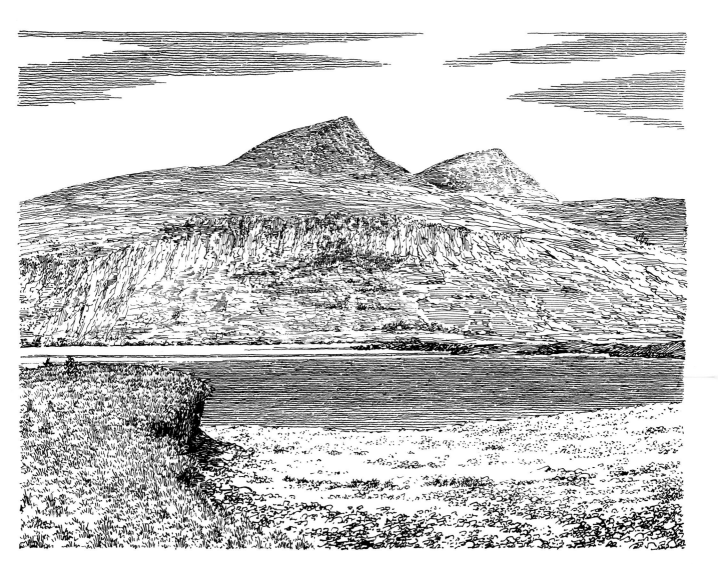

From this viewpoint Corra Beinn is the more dominant of the two mountains illustrated, but from further along Loch Scridain they appear as identical twins, the similarity extending even to their altitude. The fine old bridge in the foreground, formerly carrying the road to Iona, is now obsolete but has been kept in repair by public subscription.

433 Cruachan Dearg, 2309'
and
Corra Beinn, 2309'

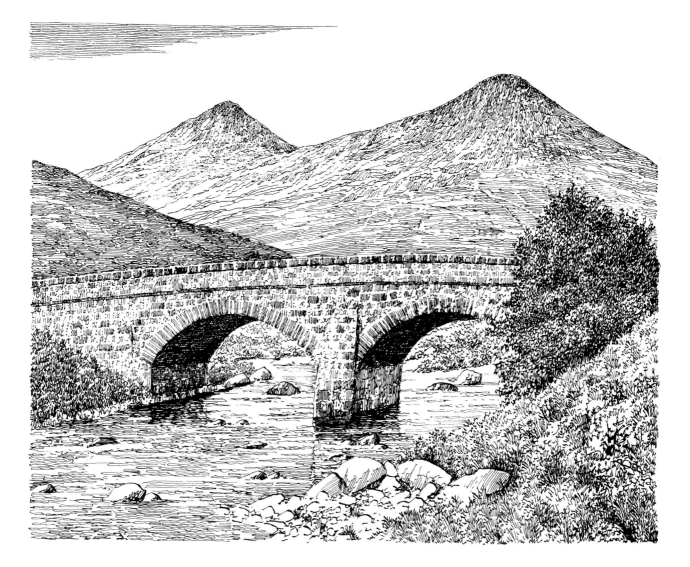

These mountains overlooking Glen More form part of a long horseshoe ridge of seven summits. The new bridge on the improved road to Iona, in the foreground, compares most unfavourably in appearance with the old one nearby (drawing 433).

434 Beinn a' Mheadhoin, 1975'
and
Cruach Choreadall, 2026'

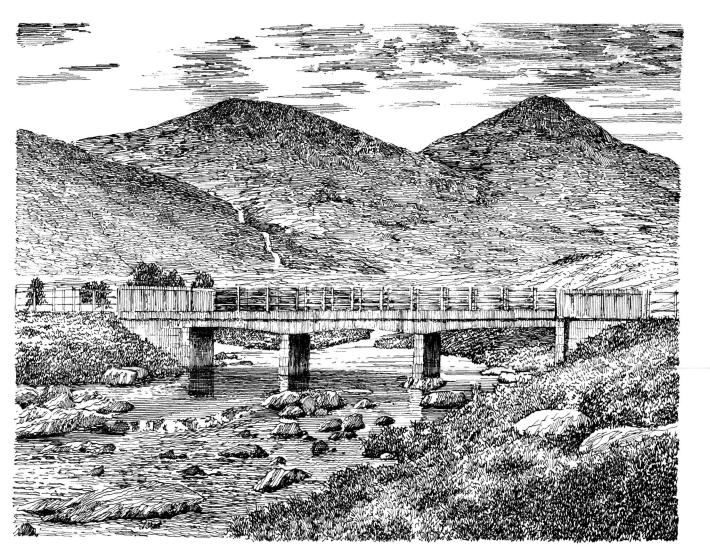

Ben Talaidh is the shapeliest of Mull's mountains,
appearing from all directions as a huge dome
isolated from neighbouring heights. It ranks
second only to Ben More in prominence in the
Mull landscape and is especially impressive
on the journey west along Glen More.

435 Ben Talaidh, 2496'
(Ben Talla)

Ben Talaidh
△

A.849

Glen
More

SALEN
IONA

CRAIGNURE
①

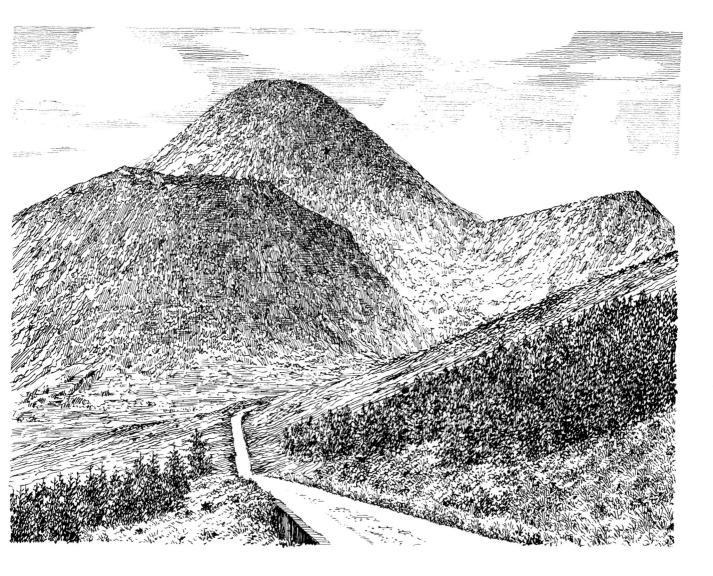

Lochbuie is the loveliest corner of Mull, remote from the Iona traffic, and, in a bower of trees and flowers and rampant rhododendrons, marks the end of a quiet side road from Glen More. It has many features of natural and antiquarian interest, not least the stark tower of Beinn Buie overlooking the pleasant scene.

436 Beinn Buie, 2354'

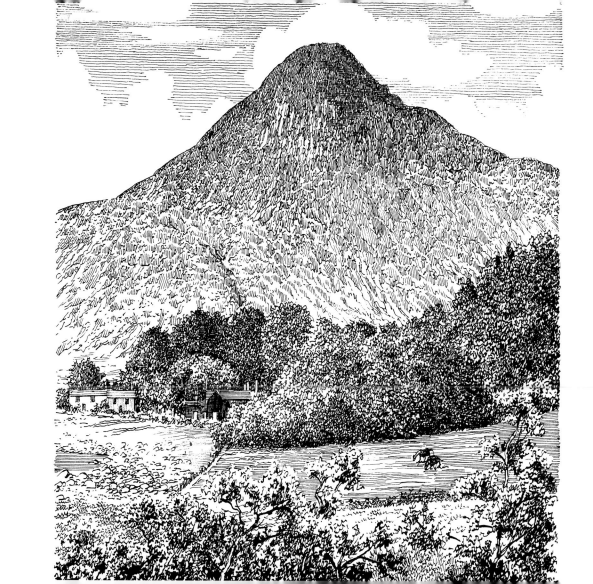

The approach to Craignure by boat brings
into view, far above, the culmination of
a long ridge overlooking the Sound of Mull,
with the two highest summits linked by
a lofty skyline.

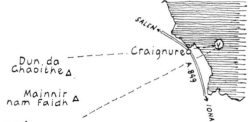

437 Mainnir nam Faidh, 2483'
 and
 Dun da Chaoithe, 2512'

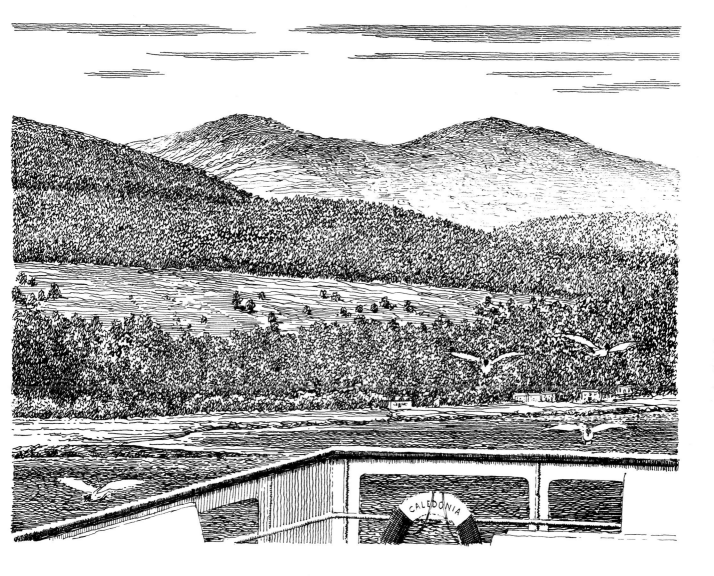

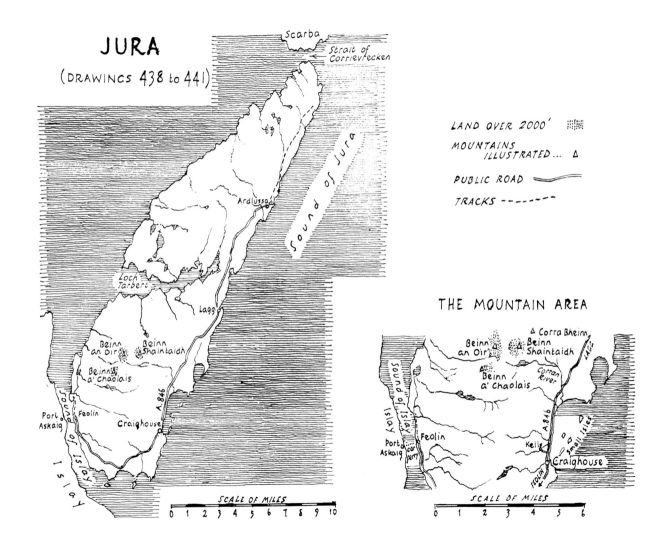

JURA

(DRAWINGS 438 to 441)

Scarba

Strait of Corrievrecken

Sound of Jura

Ardlussa

Loch Tarbert

Lagg

Beinn an Oir

Beinn Shaintaidh

Beinn a' Chaolais

Port Askaig

Feolin

Craighouse

A.846

Sound of Islay

Islay

LAND OVER 2000'

MOUNTAINS ILLUSTRATED ... △

PUBLIC ROAD

TRACKS -------

SCALE OF MILES
0 1 2 3 4 5 6 7 8 9 10

THE MOUNTAIN AREA

△ Corra Bheinn

Beinn an Oir △ △ Beinn Shaintaidh

Beinn a' Chaolais

Corran River

LAGG

Sound of Islay

A.846

Port Askaig

car ferry

Feolin

Keils

Small Isles

FEOLIN FERRY

Craighouse

SCALE OF MILES
0 1 2 3 4 5 6

Jura is best known, among mountaineers, for a splendid cluster of peaks forming a conspicuous landmark across the many miles of water separating the island from the mainland and a guide for mariners approaching from the Atlantic. They are known collectively, not without good reason, as the Paps of Jura, although, being three in number, not in accordance with biological accuracy. In shape they are beautifully proportioned mountains, conforming to most people's idea of how mountains should look: as graceful pyramids rising sharply from a low base. On closer acquaintance their distinctive outlines are less in evidence, and they are best viewed from a distance, either from the seas around or, better still, from mid-Islay, where they appear as symmetrical domes. On still closer acquaintance their steep slopes are revealed as largely covered by quartzite screes, calling for care in ascent.

Jura is the loneliest of the large islands although separated by only a narrow channel from the better-known and more populous Islay. It has one road, a single-track strip of tarmac running along the south and east sides for some 25 miles from the ferry at Feolin to Ardlussa, serving a distillery and a small community at Craighouse and a very few scattered habitations. Most of the island is a wilderness, a vast deer forest, with a western coast of cliffs and sea-caves, and, notably, a continuous raised beach several miles in length. Off the northern end is the notorious Whirlpool of Corrievrecken. All is peace on Jura. It has been spared despoliation in every sense despite the menace of afforestation, as yet on a restricted scale.

The island is usually reached by car-ferry from Port Askaig in Islay. There are no bed-and-breakfast signs, no caravan sites, but there is a good hotel at Craighouse and a few cottages here may take visitors. Accommodation should be reserved in advance. Jura is a beautiful island, but to a traveller on the last ferry of the day who is unable to find a bed for the night it must seem the most inhospitable place on earth. One needs to be comfortable to appreciate beauty fully, and Jura deserves a planned and pre-arranged visit.

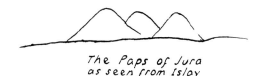

The Paps of Jura
as seen from Islay
near Bowmore

The viewpoint is the deck
of the car-ferry from
Kennacraig to Port Askaig

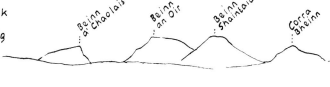

Beinn
a'Chaolais

Beinn
an Oir

Beinn
Shaintaidh

Corra
Bheinn

438 The mountains of Jura

Beinn Shaintaidh is the most accessible of Jura's mountains, being nearest to the road, and it is usual to combine its ascent with that of Beinn an Oir, a mile beyond. Their aspect is deterring, long runs of scree obviously making climbing arduous.

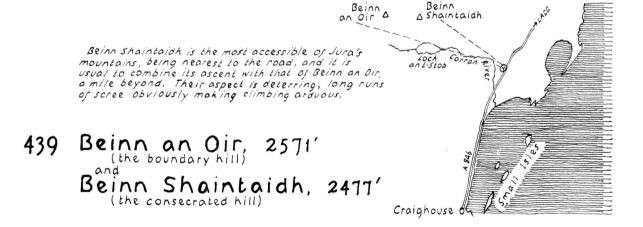

439 Beinn an Oir, 2571'
(the boundary hill)
and
Beinn Shaintaidh, 2477'
(the consecrated hill)

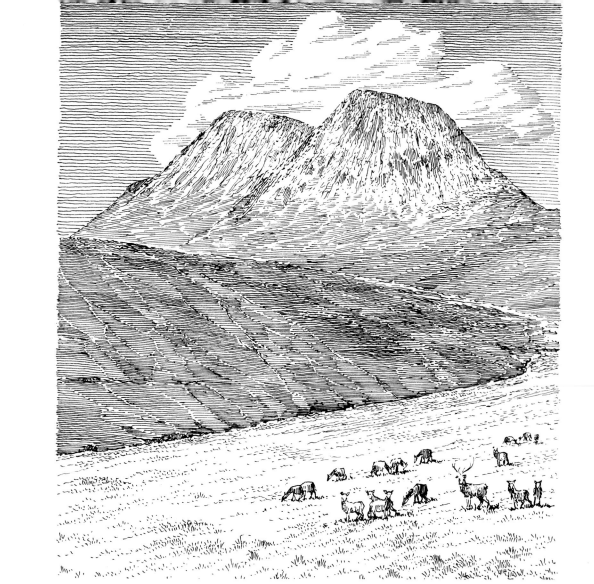

Beinn an Oir is the highest of the Paps,
Beinn a' Chaolais the lowest, but they are
alike in the steepness and roughness of
their slopes facing the Sound of Islay,
across which they are seen to advantage.

440　Beinn an Oir, 2571'
　　　and
　　　Beinn a' Chaolais, 2407'

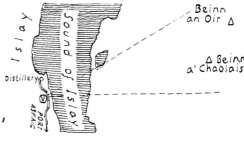

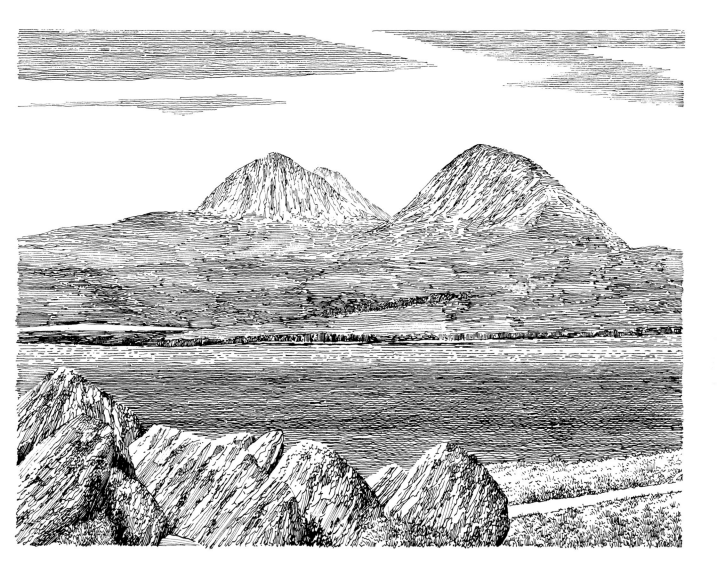

Port Askaig is a place of call for the car-ferry from the mainland and also operates a service to Feolin on Jura. Its busy little harbour (at present being enlarged) makes an animated foreground for a picture of Beinn a' Chaolais, the nearest and most prominent of the Paps.

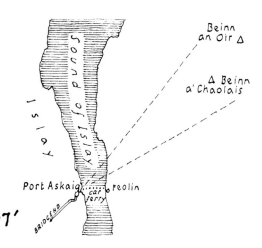

441 Beinn a' Chaolais, 2407'
(the Hill of Kyle)

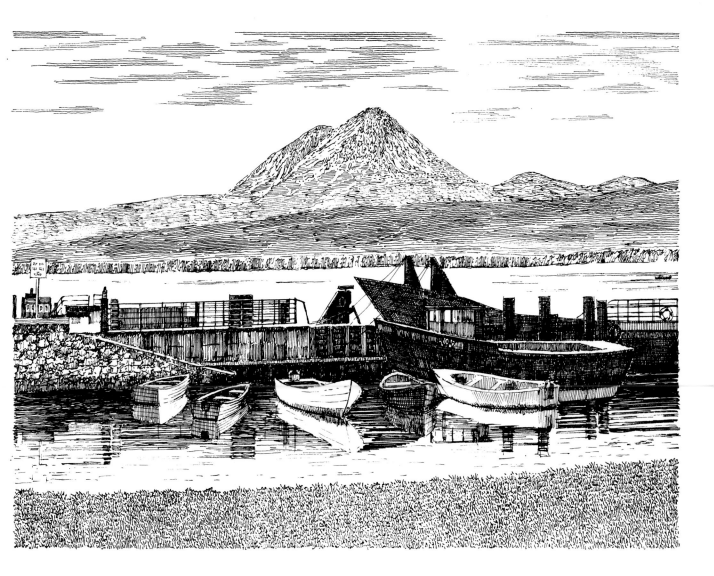

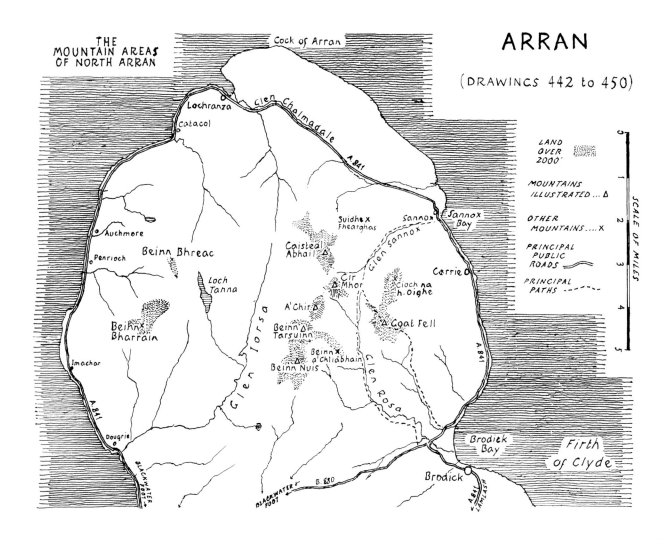

THE MOUNTAIN AREAS OF NORTH ARRAN

ARRAN

(DRAWINGS 442 to 450)

Cock of Arran

Lochranza
Catacol
Glen Chalmadale
A 841

Auchmore
Beinn Bhreac
Penrioch
Loch Tanna
Beinn Bharrain
Imachar
A 841
Dougrie

Suidhe x Fhearghas
Caisteal Abhail △
Cir Mhor △
A'Chir △
Beinn Tarsuinn △
Beinn x a'Chliabhain
Beinn Nuis △

Sannox x
Glen Sannox
Sannox Bay
Corrie
x Cioch na h.Oighe
△ Goat Fell
Glen Rosa

Glen Iorsa

A 841

Brodick Bay
Brodick

BLACKWATER FOOT
B 880
BLACKWATER FOOT
A 841 LAMLASH

Firth of Clyde

LAND OVER 2000'

MOUNTAINS ILLUSTRATED ... △

OTHER MOUNTAINS X

PRINCIPAL PUBLIC ROADS

PRINCIPAL PATHS ---

SCALE OF MILES

Guidebooks describe Arran in extravagant terms: as a treasure island, an enchanted island, a paradise of fine mountains and heather moors, of crystal streams and sparkling lagoons, of exquisite loveliness. And they are right. Arran is all these things, and more. It is a holiday island, but undefiled; a place where its many visitors must find their pleasures in natural beauty, not in noisy funfairs and amusement palaces. And natural beauty abounds. Arran is a world away from the busy industrial areas of the mainland, and it is quite remarkable that on such a short sea crossing one passes into a wholly different and refreshing environment of tranquillity. Visitors come to Arran because it is as it is: an island of infinite charms, an island of peace.

The principal mountains make a compact group in the northeast, conveniently within reach of the main village, Brodick, where the boats arrive. They are splendidly arranged around the very lovely Glen Rosa and the wild Glen Sannox, forming two distinct parallel ridges linked centrally by Cir Mhor, an elegant and challenging peak. These mountains, of outcropping and exposed granite, have a character and an atmosphere all their own. They offer exciting walks along interesting ridges that lead to dramatic situations in surroundings of impressive grandeur yet are safe for those who tread carefully. Imposing crags provide sport for rockclimbers, but the main appeal of these hills is to walkers who love exhilarating days on the tops. None of them are Munros, yet few Munros give more pleasure and satisfaction in ascent. Goat Fell is the highest and a popular climb from Brodick, which it overlooks, but all the summits amply reward the effort of reaching them. There is magic in Arran's high places.

There is no lack of tourist accommodation in the several villages, Brodick in particular being geared for visitors, but it is in heavy demand in summer. The usual route of approach to Arran is by boat from Ardrossan on the mainland.

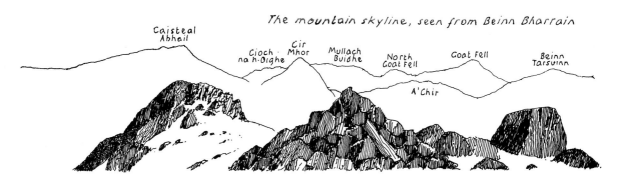

The mountain skyline, seen from Beinn Bharrain

Caisteal Abhail — Cioch na h-Oighe — Cir Mhor — Mullach Buidhe — North Goat Fell — Goat Fell — A'Chir — Beinn Tarsuinn

Goat Fell is Brodick's Matterhorn, and for all active people staying in the village its ascent is almost a ritual; perhaps fortunately this is the easiest climb on the island and has the advantage of a clear path to the top. Its most interesting features lie beyond the summit in a series of spectacular granite tors.

442 Goat Fell, 2866' (the hill of the wind)

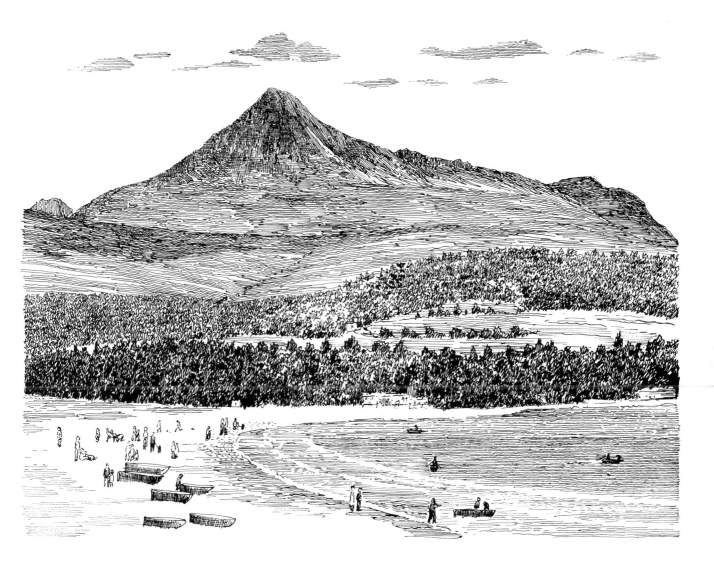

*Looking from Caisteal Abhail over the head of Glen Sannox
the most arresting scene is the precipitous north face
of Cir Mhor, an awesome abyss of rock cleft by gullies.
Behind, to the left, are the summit ramparts of Goat Fell.*

**443 Goat Fell, 2866'
and
Cir Mhor, 2618'**

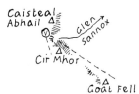

Cir Mhor (pronounced Keer Vore) is almost the perfect mountain and certainly one of the finest in Scotland. It appears from all directions as a steep and rocky pyramid of symmetrical outline rising to a small and delicate summit – a thrilling viewpoint. The only easy line of ascent is by the west ridge, the north and south flanks in particular being out of bounds for ordinary mortals.

Caisteal
△ Abhail

ⓥ △ Cir Mhor

△ A' Chir

444 Cir Mhor, 2618′ (the great comb)

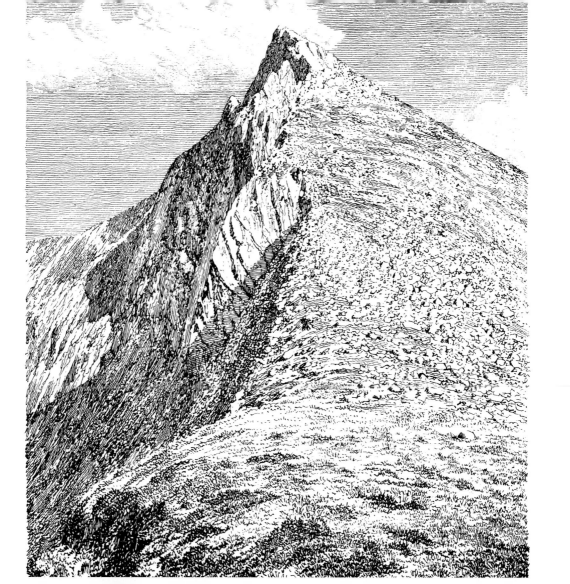

The viewpoint is the
northwest ridge of Goat Fell

445 Cir Mhor, 2618'
and
Caisteal Abhail, 2817'
(Ptarmigans' Castle)

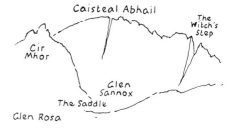

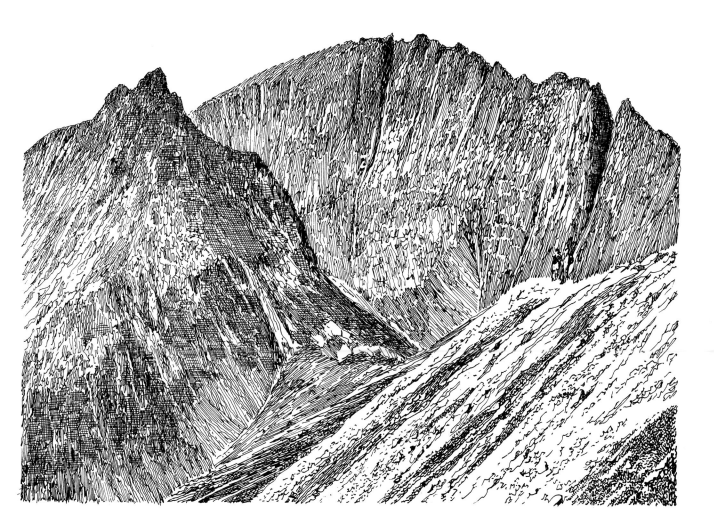

A'Chir is the one mountain ridge in Arran that cannot be traversed without difficult scrambling, and has an exposed section ("the Bad Step") that non-rockclimbers would do well to avoid. It is usual to bypass the ridge by using a path below the cliffs on the western side.

△ Cir Mhor
△ A'Chir
△ Beinn Tarsuinn

446 A'Chir, 2335' : the west flank
(the Comb)

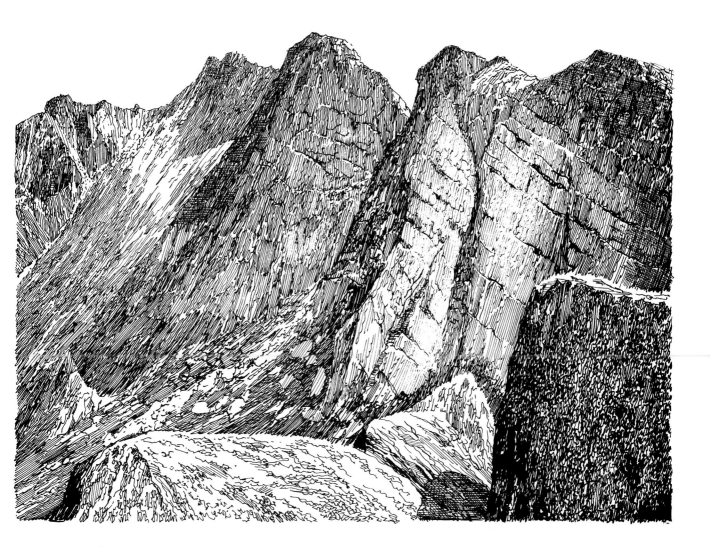

The west flank of A'Chir is formidable but broken by gullies some of which give easy access to the ridge, but the east flank is utterly relentless and has no such weaknesses. Palpably there are no ways here for walkers.

A'Chir

Beinn Tarsuinn

Δ Beinn a'Chliabhain

447 A'Chir, 2335': the east flank

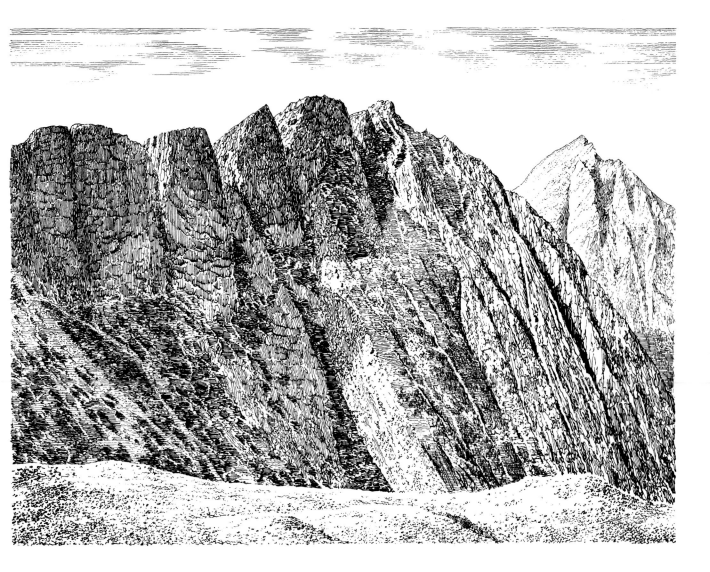

The main feature of Beinn Nuis is its great eastern cliff, which has an honoured place in the climbing literature of Arran. This mountain is the southern terminus of a continuous ridge west of Glen Rosa and Glen Sannox and overlooks a wide heather moorland to the south.

448 Beinn Nuis, 2597'
(the face mountain)

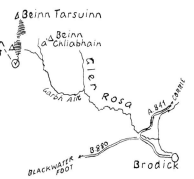

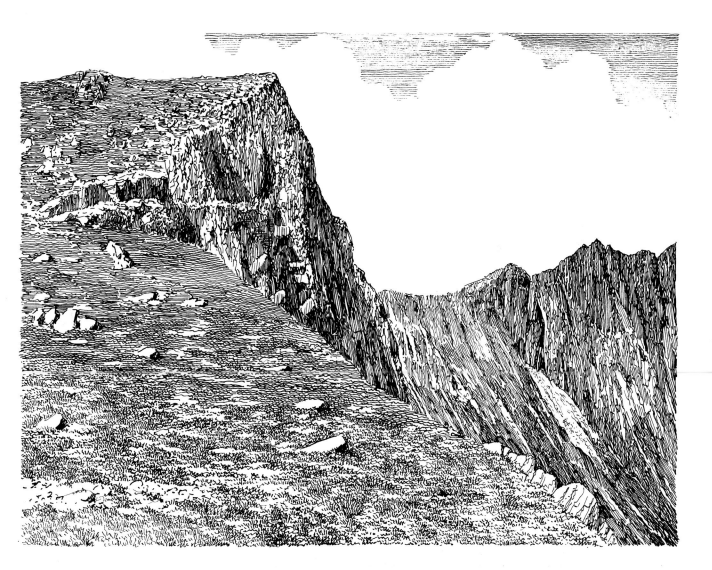

Beinn Tarsuinn, a splendid viewpoint, continues the ridge
north from Beinn Nuis, and is defended by uncompromising
cliffs on its east side. From the summit there is a simple
descent to the Bealach an Fhir-Bhogha, beyond which rises
the pinnacled crest of A'Chir.

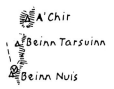

449 Beinn Tarsuinn, 2706'
(the transverse mountain)

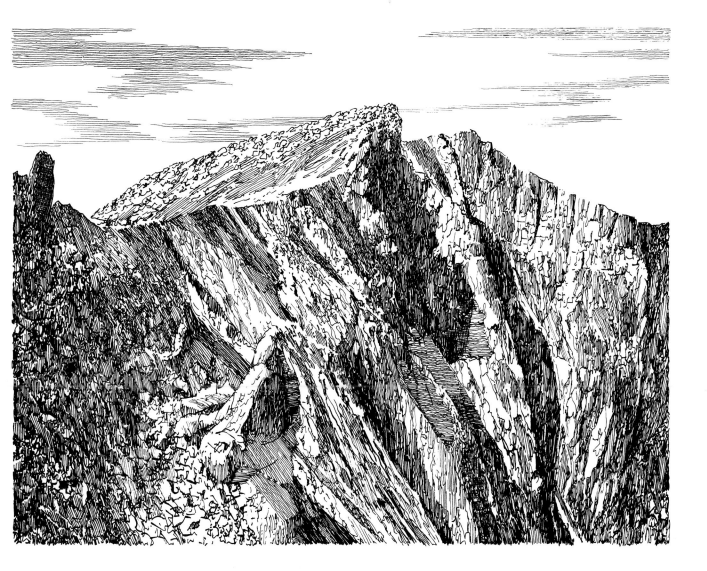

A feature of the ridges of Arran, not found to the same extent elsewhere, is the succession of granite tors and piled boulders that add an unusual and decorative adornment. Illustrated is a striking example of rock architecture on Beinn Tarsuinn (although one suspects that the 'eye' has been added by human agency).

450 A granite tor, Beinn Tarsuinn

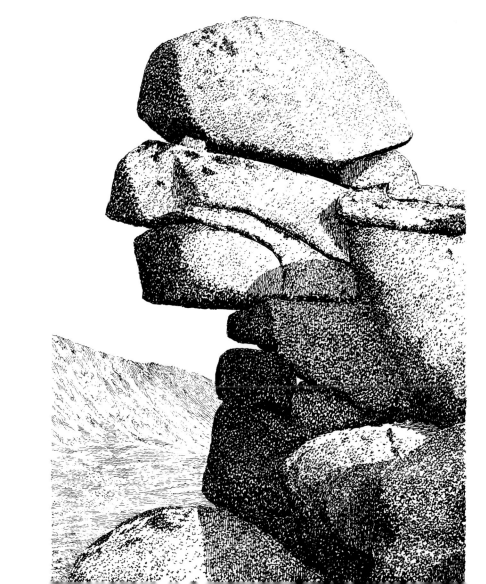

A. WAINWRIGHT

Born in Blackburn in 1907, Alfred Wainwright left school at the age of thirteen. A holiday at the age of twenty-three kindled a life-long love affair with the Lake District. After moving to Kendal in 1941 Wainwright devoted every spare moment he had from then until 1966 to researching and compiling his remarkable Pictorial Guides to the Lakeland Fells.

Five volumes of Wainwright's intricate pen-and-ink drawings of Lakeland scenery were published in the late sixties and early seventies. Twenty-four more volumes of drawings of landscapes in England, Scotland and Wales followed, including this collection and five further volumes of Scottish Mountain Drawings.

A. Wainwright lived to see his Pictorial Guides to the Lakeland Fells achieve sales he never dreamed of when he set out on his labour of love, as he called it. He died in 1991, at the age of eighty-four.

THE WAINWRIGHT SOCIETY

Set up in 2002 to celebrate the work of Wainwright, the Society publishes a quarterly newsletter and organises an annual Memorial Lecture by a guest speaker. There are also monthly walks in areas covered by Wainwright's books. For full details of events and information on how to become a member, visit www.wainwright.org.uk or write to the Membership Secretary at Kendal Museum, Station Road, Kendal, LA9 4BT.